Professional Secrets for
PHOTOGRAPHING CHILDREN

Douglas Allen Box

AMHERST MEDIA, INC. ■ BUFFALO, NY

Published by:
Amherst Media, Inc.
P.O. Box 586
Buffalo, N.Y. 14226
Fax: 716-874-4508

Publisher: Craig Alesse
Senior Editor/Project Manager: Richard Lynch
Associate Editor: Michelle Perkins

ISBN: 0-936262-76-1
Library of Congress Card Catalog Number: 98-72978

Printed in the United States of America.
10 9 8 7 6 5 4 3 2 1

Dedication and Special Thanks:
I would like to dedicate this book to my sons, David and Derrick. Although I had been photographing children several years prior to their birth, I don't think I knew why children's portraits were so important until I had children of my own. They were usually willing subjects and let me try out new techniques on them. They taught me one very important thing: the love between a parent and a child. Understanding this relationship makes me a more sensitive photographer. Portraits are memories! I wouldn't trade my memories for anything!

There are a lot of people to thank. First, my dad who got me started taking pictures, loaning me equipment and buying me my first camera. His best photographic advice, "When taking pictures on vacation, the photographs that have the most meaning are those with friends and family in them. Don't worry about getting great shots of the animals at the zoo or the magic castle. Concentrate on images that include your children. Those are the ones that will create the best memories."

I also want to thank all of the instructors and teachers who have unselfishly shared their photographic knowledge. They took me from taking pictures to making portraits. A special thanks to Les Peterson, Broken Arrow, OK, for sharing his portrait guidelines and concept of "play time" with me. Thanks to the parents who trusted me to capture their special memories. But most of all I want to thank the children. They make me look good. They are so beautiful and special. They have kept me young at heart and taught me how to enjoy the wonderment of life!

Table of Contents

Introduction

Photographing children can be fun, if you know the secrets. It can also be rewarding, both financially and artistically. I consider children young adults. When talking to them, show respect not only for their feelings, but also for their intellect. I have found that children are much smarter than they let you think. I will admit, though, it does help to be a "child at heart." To work with kids well you should enjoy playing games and pretending. You should enjoy sitting on the floor, and crawling on your hands and knees. You should enjoy being silly and laughing a lot. If you don't enjoy all of these things, that's OK – just get someone in the camera room who does. Then you can hide behind the camera, be quiet, and take the photographs.

Kids just want to have fun. If you can make sure that all of the children who come to you for photography have fun, they will want to come back. There are lots of different kinds of children: shy, timid, outgoing, silly, serious, and so on. When photographing a child, the job is two-fold: find out your subject's personality type, and decide how to bring that out in a fun way.

In this book, I'll share the tricks of the trade which I have learned from years of experience. So much could be said about every image – techniques for metering, film selection, posing, placement of lights, clothing selection, etc. I have organized this book to include all of that information, spread out through the pages and discussed in reference to the images where each topic is most relevant. Additionally, the book is divided into several sections. The first section deals specifically with images shot in the studio. The second moves on to discuss images taken outdoors and on location. Finally, the last two sections cover photographing children at weddings, and a creative way to shoot and display your photos in a storybook format.

Photography is one of the greatest professions in the world, giving us the ability to touch people and create memories in ways other professions can only imagine. Remember, the goal is great photography (and greater sales), so good luck – and be silly!

Studio Images

A good portrait of a child can never be rushed. Reserve plenty of time for each portrait session, and make sure to leave yourself time to build trust with the child before the session.

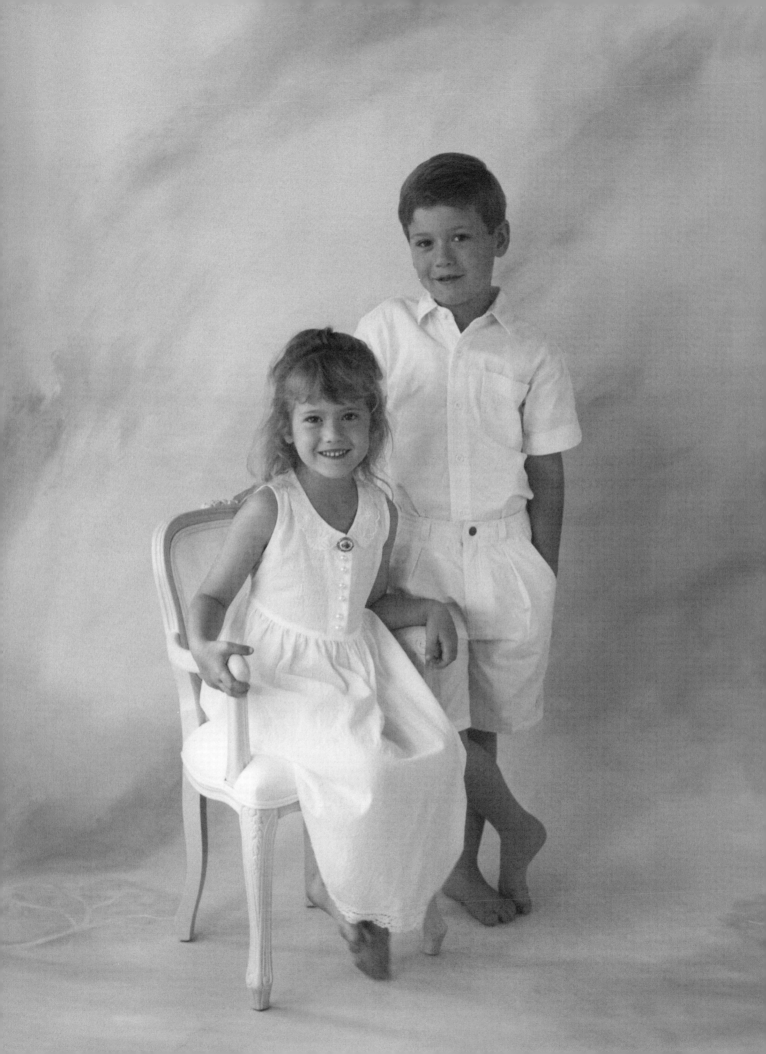

Two Children in White

Pose

This crossed leg pose of the little boy is always cute. If boys have pockets, use them. With one hand in the pocket, you have one less hand to worry about. The girl is in a simple sitting pose, but notice how much nicer it is with her feet crossed. When posing two children of different heights, I usually seat the taller child and let the shorter child stand. The goal is that their heads be at different heights, but not too far apart.

Prop

The chair is a Louis XV chair from American Photographic Resources (contact them via the suppliers' list in the back of this book). It is a great prop for children. Its elegant lines and white/off-white color scheme make it very versatile.

Background

This is a painted background with soft pastels on an off-white base. It is from Les Brant (see the suppliers list in the back of this book).

Photography

The window to the left of the camera provides the illumination for the image. A reflector was placed to the right side of the camera. Place the reflector slightly in front of the subjects. This allows the light to wrap around them. The 120mm lens on the Hasselblad is great for photographing in small rooms. It gives you all of the benefits of a telephoto lens: separation from the background, lack of distortion of the subject that sometimes happens with normal or wide angle lenses, and the ability to move back from your subject and make them feel more at ease. Because it is slightly shorter focal length than the popular 150mm, you can take full length portraits even in fairly tight quarters. It will also focus closer than the 150mm. The film used was Kodak PPF.

Psychology

I find that if you act silly with children you can get very natural, happy expressions. Sometimes I will ask them, "Are you married?" or I ask boys, "Is your name Mary?" Another trick that always seems to work is I ask the children to "Give me five!" When they do I say "Oooow!" and pretend it hurts. I don't know why, but most children find this funny. At first it surprises them, then every time they give you five and you say "Oooow!" they laugh.

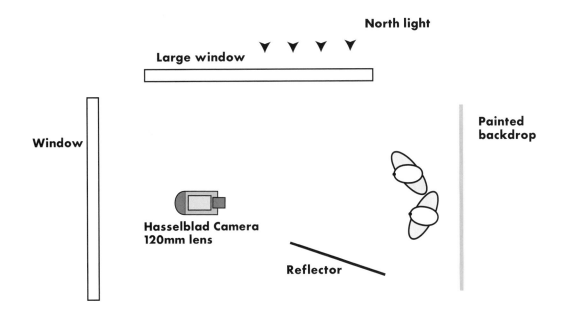

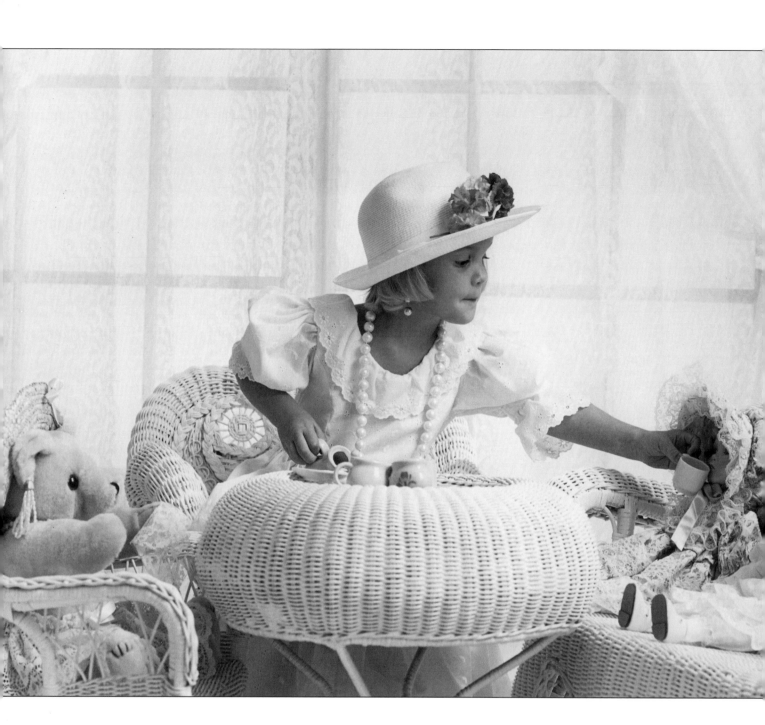

Tea Time

Pose

This was photographed as part of my Heirloom Series (for more on this see pg. 40). I like to let children pose themselves. I set up the situation, then before I let the children get in the set, I talk to them about what we are doing. You may want to tell them a story about what is happening. Then just watch what they do. Give them ideas as the session proceeds.

Prop

The little wicker table, bench and two chairs are the basic set up for this scene. The bears and the hat are part of the prop collection at the studio.

Background

The background is our basic high key set-up. Then I slid the window frame with curtains into place. The light comes through the curtains for a nice look (for more information on the background see pg. 12).

Photography

When photographing a child with a hat, make sure that the main light (the light illuminating the face) is low enough to get under the brim of the hat and illuminate the eyes. The exposure was 1/60 at f-8.5, film was Kodak TXP rated 200.

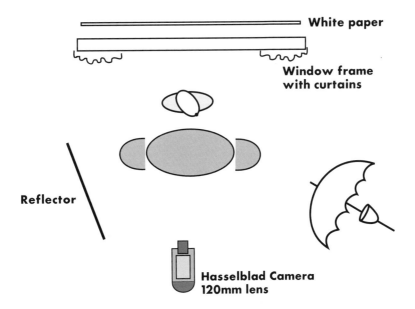

White paper

Window frame with curtains

Reflector

Hasselblad Camera 120mm lens

Peek-a-Boo Baby

Pose

This pose works great for children 2-4 months old. Place the young child on his/her tummy, propped up on a pillow. If the child cannot hold his head up very long, I will reach up and hold the child's hands together directly under his chin. This allows the child to rest his head on the back of my hand while keeping the baby's hands together for more support. As soon as the child raises his head, quickly move your hand and take the photograph.

Prop

The baby is posed on our "fake bed." I always ask moms to bring their own blankets to lay the children on. This makes it more personal. This is a favorite pose when children can begin to lift their heads.

Photography

This is a slight variation on my regular high key lighting set-up. I placed a small light head just above the camera (in the corner formed by the back wall and the ceiling) pointing at the place where the wall meets the ceiling. This light is the fill light. The advantage of using fill light instead of reflector fill is

one less stand, and the fact that you don't have a reflector in the way. Here I chose this method so the mom could stand next to the child and prevent falling. Either method is contingent on the dynamics of the room. This room is small and has white walls, floor and ceiling. The film used was Kodak VPS.

Background

The background is white paper. The baby is laying on a white blanket over a small flat pillow.

Psychology

Another request I make of parents is not to bring relatives and friends to the portrait session. Extra people only serve as a distraction and result in poor portraits. Be sure to ask that parents leave other children with a sitter. Choose the time of day when the child to be photographed is happiest and at his very best. Never schedule a portrait session near nap or meal times. Also, request that the parent and child be ready for their session on time. Lateness causes us to rush, and since we want the best for our clients, we don't want to rush a portrait session. We might ask them to make a new appointment for another day.

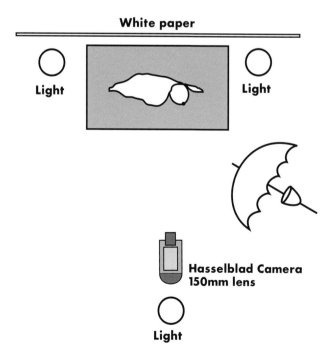

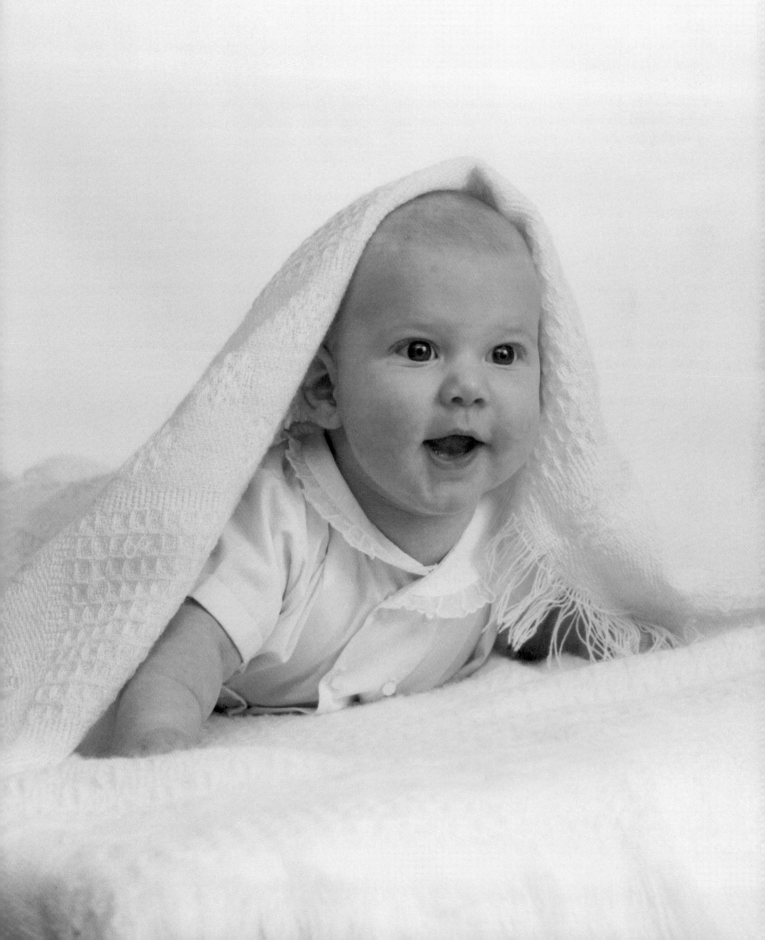

Sisters

Pose

This is the basic dance pose. I use this for children, engagement photographs, at proms and with other couples. This results in a full face on the little girl and a 2/3 view on the older girl. When I was posing this I had to make the decision whether to raise the small girl up to bring the heads closer together, or keep them at their real height. I chose the latter.

Prop

The girls had gotten the dresses and the hair pieces for a special party. They make for a nice feel in the portrait.

Background

This window is made by purchasing a set of frames used for double glazed windows. I built a frame for them to rest in using 1"x 6" boards. A set of sheers are in front of the frames. White curtains are hung to replicate a real window.

Photography

This is one of the few photographs in this book that uses a fill light. Most of the time I use a reflector for fill. I used it this time to help lighten the curtains. The problem most people have with a fill light is they use too much power. This causes the photograph to be over-filled, giving a flat look to the faces. I set the fill light two stops below the main light. The film used was Kodak VPS.

Psychology

Sometimes it is best to have a parent in the room while a child is being photographed, sometimes it is not. I make that determination when I meet the child. I ask the parents to please cooperate with us in this matter. One of the reasons that I do like having a parent in the room is that they can watch for little things with the children's hair and clothing. When the parent stays in the room, I ask them to move to the back or out of the child's sight. This keeps the child concentrating on me, but lets the parent see the way I work their child.

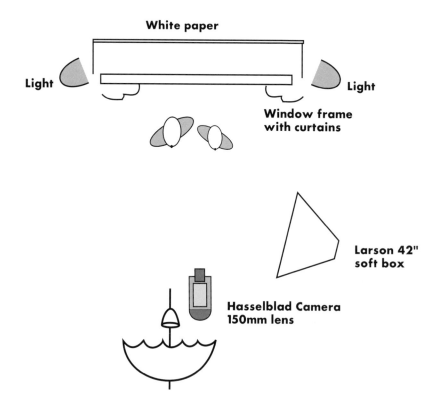

White paper

Light

Light

Window frame
with curtains

Larson 42"
soft box

Hasselblad Camera
150mm lens

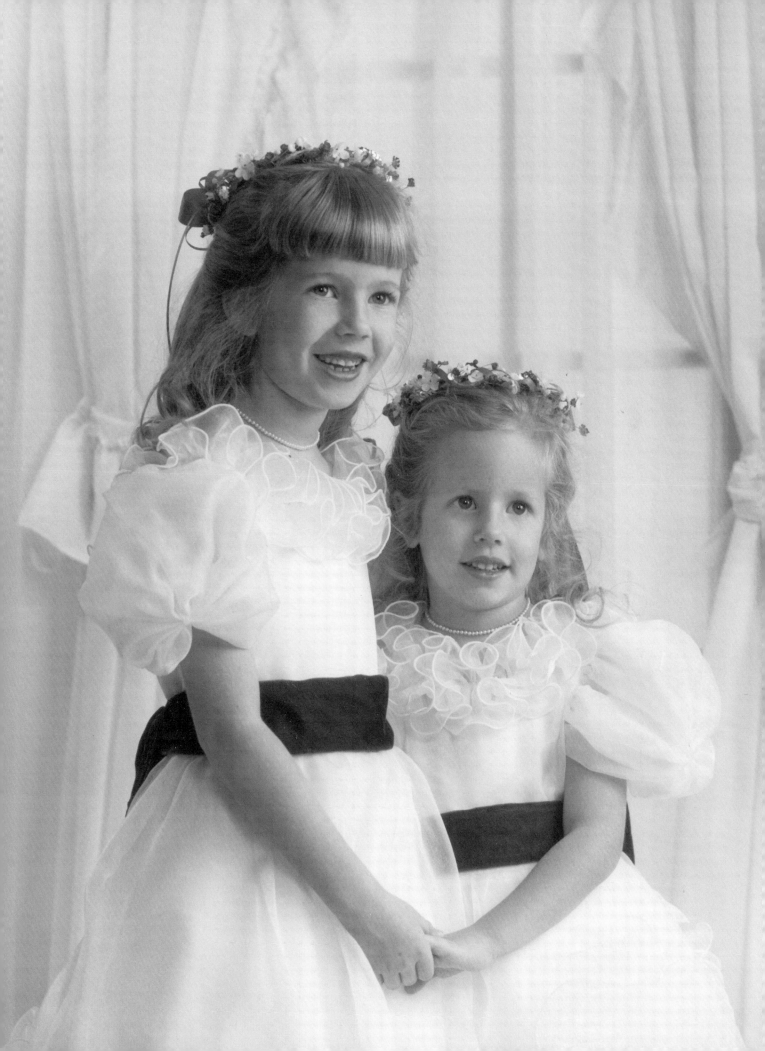

Up and Away!

Pose

The pose was easy. It is a simple sitting pose, with the child holding the ribbon in his hands. The hard part was getting this cute little boy to hold the reigns in the right position and look at mom with a nice expression. It took four or five takes to get this image. Patience is a virtue when photographing children!

Props

I enjoy involving the clients in planning the images. I also like when they bring the props. This keeps the photographs new and exciting, saves me money, and keeps the storage situation manageable. All of these props belong to the parents.

Background

White paper is the background. The sleigh is propped up on a couple of blocks, covered by a white furry cloth. The deer is suspended by clear fishing monofilament.

Photography

To give the illusion of upward movement, I tilted the camera clockwise. I like to use an umbrella in this white room. I shoot through the umbrella for a softer, broader light source. Using the umbrella like this allows light to bounce out of the umbrella around this small room and fill in the opposite side of the face. The film used was Kodak VPS.

Psychology

This is one of those situations where you have to strike a careful balance between a happy, expressive child and one that will fall or jump out of the sleigh. He kept wanting to let go of the reigns. To prevent that from happening, I would get the mom to put them in his hands and gently put her hands completely around his, to "make" him hold on. Then by talking and laughing, I drew the boy's attention away from his hands and toward his mom.

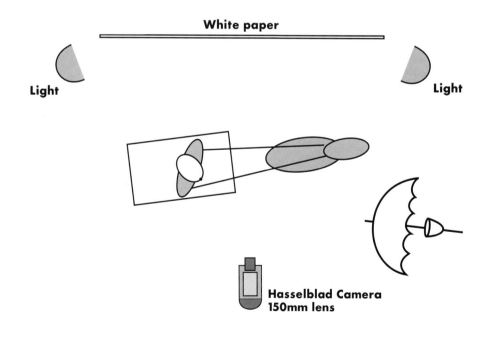

White paper

Light

Light

Hasselblad Camera
150mm lens

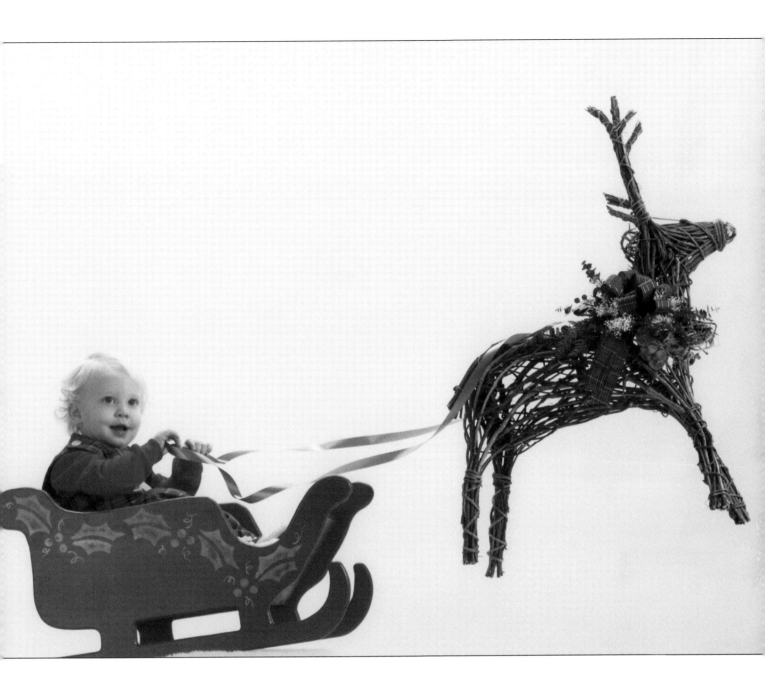

You Should Have Seen the Other Guy

Pose

This is my youngest son. When he fell and bumped his eye on a table and got his black eye, I felt I should use this opportunity for a fun photograph. I set up this little boxing ring with this yellow cording purchased at a cloth store. The cords were simply tied onto light stands in front of the high key background.

Prop

I borrowed the boxing gloves from a friend and put my son in his red bathing suit. I did a series of photographs including several poses with his older brother. One was an "action" shot. I let the older boy put on one glove and hold it pressed against his brother's cheek like he was hitting him. The hardest thing was keeping them from really socking each other.

Background

The background is simple: white paper with yellow ropes.

Photography

I mounted two small Photogenic Flash Master light heads from the ceiling and pointed the lights about half way down on the background. The light then evenly illuminated the white paper background. The main light was the umbrella with the light shining through it. The film used was Kodak VPS.

Psychology

When working with your own children, an extra measure of patience is required, at least it is for me. I don't know why I expect my children to be more cooperative than my client's children. In fact, I guess I should expect less since they know me and know what they can get away with. I have decided to make the sessions fun and not just an opportunity to try out a new background or photographic style. Make a game out of the session. With this session, fun was easy! That makes for great images.

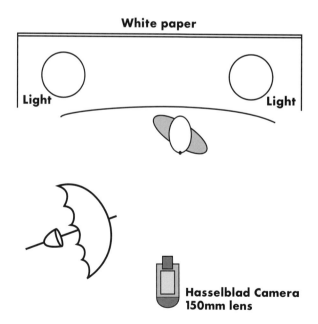

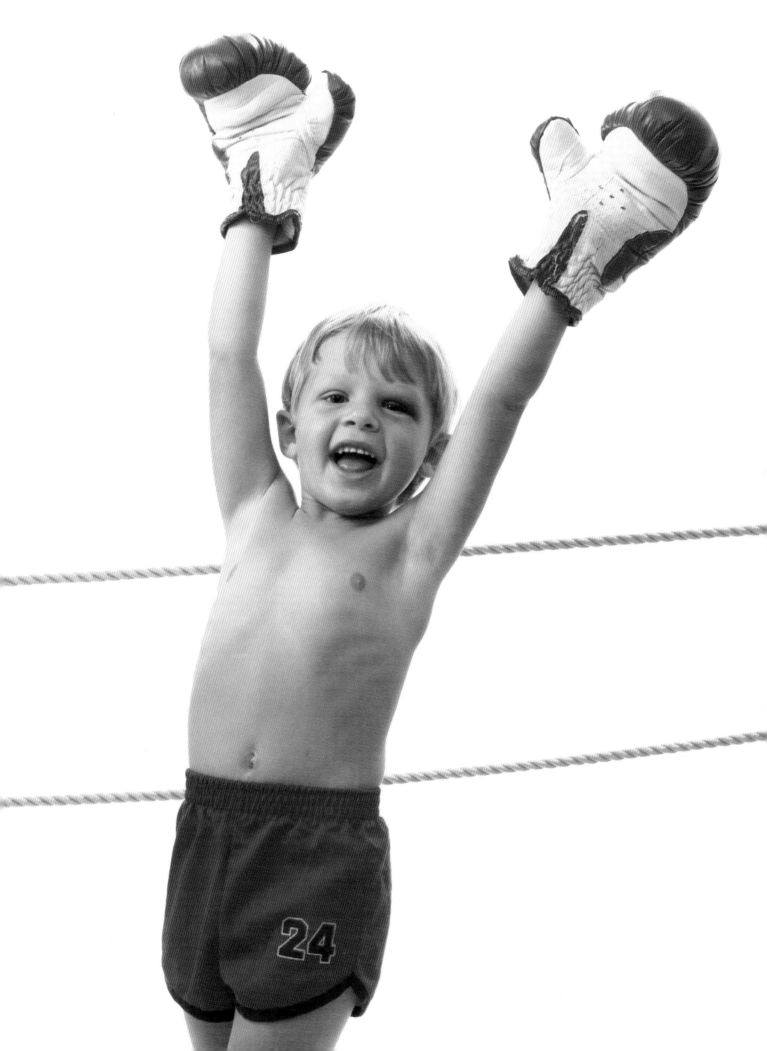

Washing the Baby

Pose

This was a fun session. The little girl really got into washing her brother. One mistake I made was putting water in the bowl before I put the boy in. As you can see, I overestimated the amount of water to use and some water spilled out ruining the white paper. But it was worth it, for this really cute image.

Prop

All of the props were bought in by the mom. It's great when you do a clothing conference to plan the session and the mother does all of the work getting the props. She found the old baby powder can at an antique store.

Background

I think this was the last roll of white paper I bought. I got tired of buying it all of the time. I painted the concrete floor of the camera room semi gloss white. Then I brought the paper down until it came out about 18" onto the floor. I taped it down to the floor with clear tape. I never had to buy paper again, just a light coat of paint every month or so.

Photography

This is another way to light a high key photograph. I mounted two small light heads on the ceiling and pointed the lights about half way down on the background. The light then bounces off the background, toward the foreground and adds light to the foreground. The main light is the umbrella with the light shining through it. When photographing more than one child I add a reflector to the scene. In this case it was needed to light the face of the boy who looked away from the main light. The film used was Kodak VPS.

Psychology

I tell parents, "If you feel your child will have a problem with shyness or they are afraid of strangers, please call the studio. We offer a free service called 'play time.' We ask that you bring your child by the studio a day or two ahead of their portrait session to meet and play with Mr. Box. This will create a bond of trust and results in better portraits. Please call for an appointment for play time." This has resulted in many children being photographed more successfully than they might have been without play time.

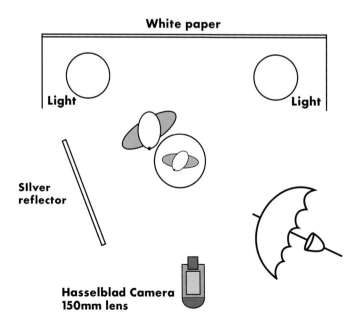

White paper

Light **Light**

Silver reflector

Hasselblad Camera 150mm lens

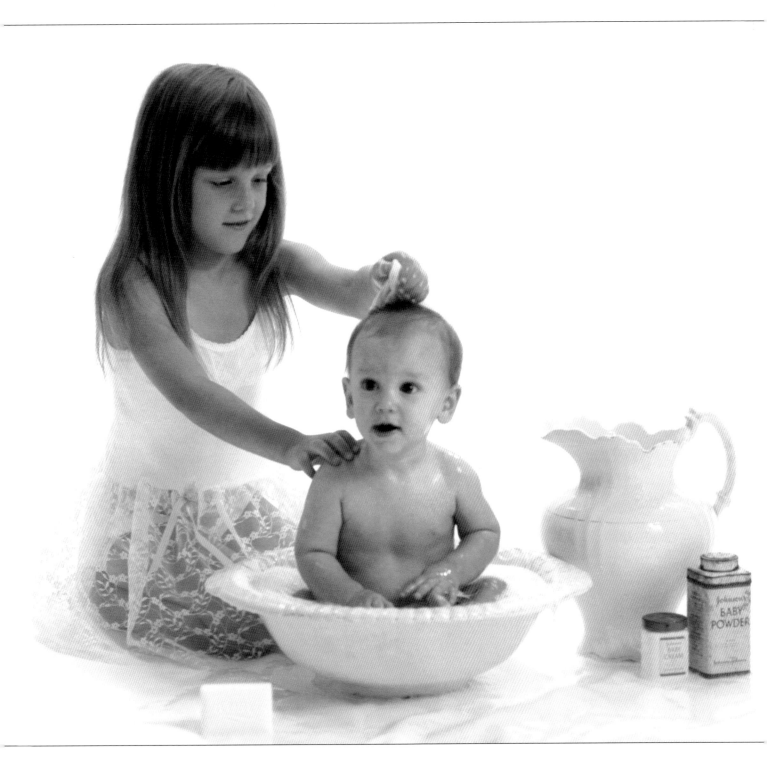

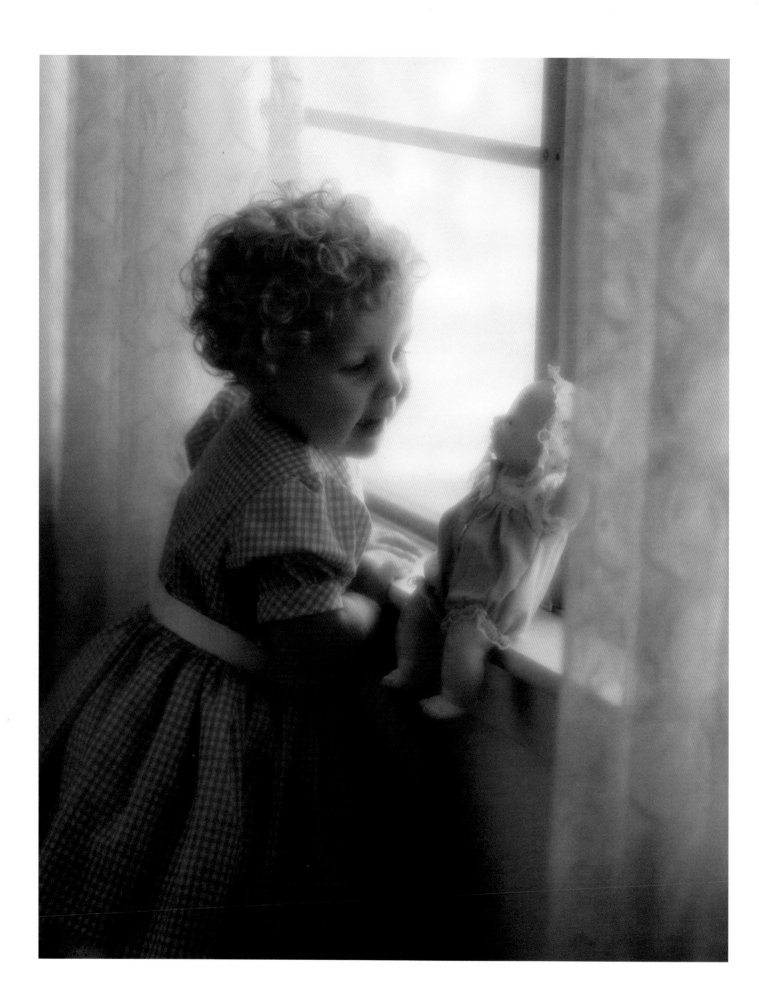

Two in Blue

Pose

I was getting ready for the session, setting the camera up, etc. I sat the doll down on the window sill while I finished getting ready. I turned around and this is what I saw. This is why I love to work with children and this is why you always have to be ready. I focused and made the exposure. I felt the camera was a little too high, so I reset the tripod and moved the camera closer to the wall to keep some of the window out of the photograph and tried to recreate this moment. It was not to happen; she would never do it again. In the end it was okay, though, because I like this one just fine!

Prop

This is a window in the sales room. I just opened the curtains. I love windows and I love window light.

Photography

As I described above, I can't take much credit for this image. I was just lucky. I did learn something important about photography from this image. I was always under the impression you could not have the light source in the photograph. It would be too bright, or so I thought. But as you can see, it will work. This is just a machine print. This is not perfect posing for the face, it is not a profile or 2/3 view. But I don't care. It is cute and everyone loves it. I guess my clients don't care how portraits are "supposed" to be. The film used was Kodak VPH.

Psychology

A portrait should show how a child looks and feels at a certain age. Our portraits are usually 3/4 or full length and often we have a child relating to things other than the camera, such as a flower, book, or toy. That is the way I like doing children's portraits. I want to capture the personality. To me, this is much nicer than a standard "smiling, looking at the camera with a blue painted background" portrait. I find this type of photograph is more challenging to take, but also more satisfying. I believe my clients will also treasure this style of image longer.

**Hasselblad Camera
120mm lens**

Heavenly Baby

Pose

This is a great pose for children 4 months or younger. I place the young child in the carriage near the right side of the window. I have found if you hold small children's hands together for 10 to 15 seconds, the child will continue to hold them together for a few more seconds.

Props

The baby is posed in a large antique wicker buggy. It is a great baby poser. It has a large pillow in the bottom to bring the children up high enough to see them even with this low camera angle. I always ask moms to bring their own blankets to lay the children on. This keeps my photographs fresh and more personalized for the client (I always keep a few blankets on hand just in case).

Background

The background is a simple white baby blanket draped over the carriage. The white on white is great for young children.

Photography

I have the mom stand at the foot of the carriage. By standing up straight the baby is forced to look up. I lower the camera angle a little, so as not to look down on the child. The window light wraps beautifully around the face. The exposure was 1/30 second at f-5.6. The film used was Kodak PPF.

Psychology

I love working with young babies. The following technique has proven to work time and time again. With the camera focused and using a long cable release, I move my face close (about 12" away) to the baby and make small kissing sounds. I move back once the child has seen and focused on my face. It usually takes two or three in-and-out movements to get the desired results. With some children, a soft clicking sound or even a gentle whistle works. Remember to be ready, many times you only get one or two chances before the trick does not work or the child's mood changes.

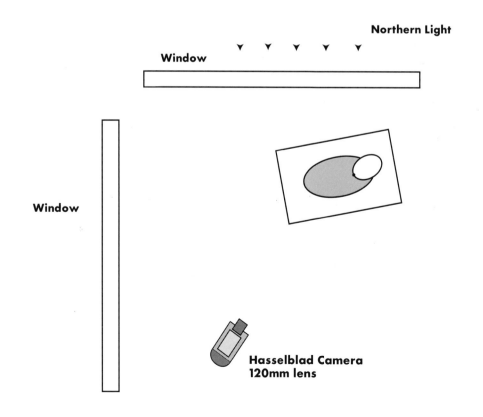

Northern Light

Window

Window

Hasselblad Camera
120mm lens

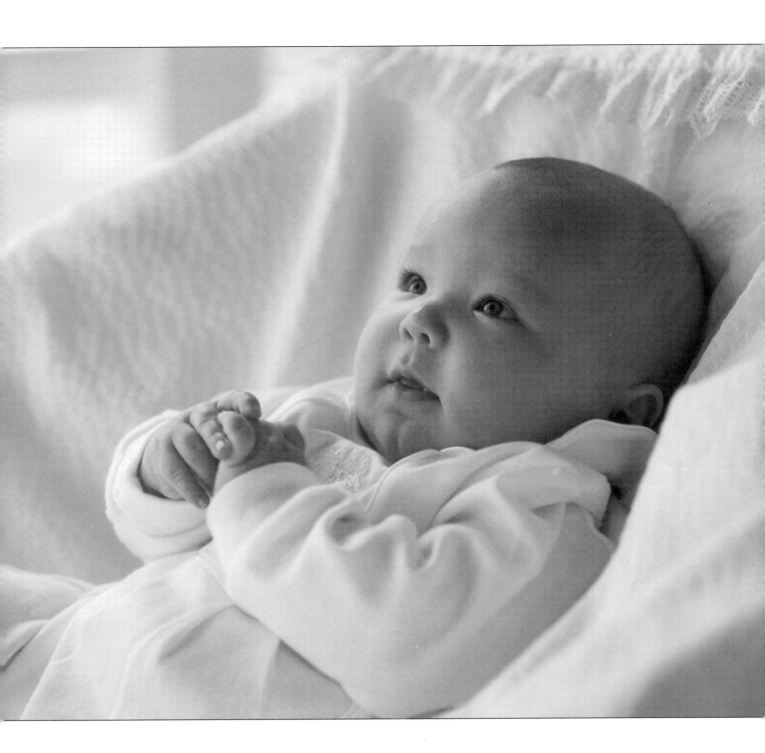

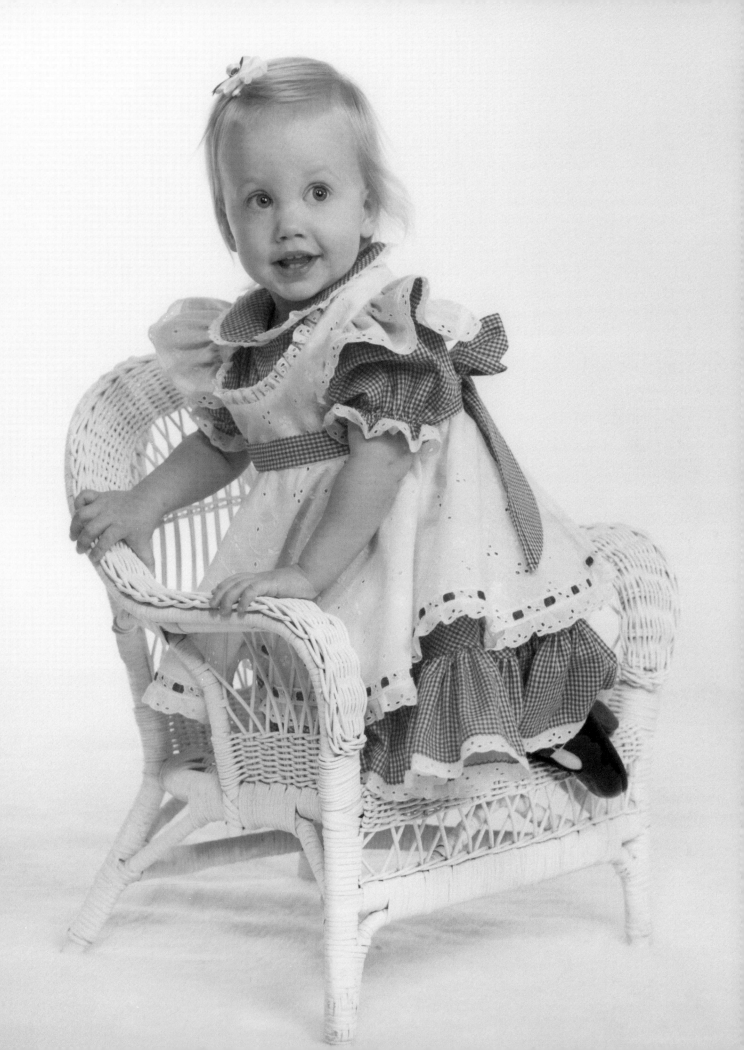

Sit Like This?

Pose

Sitting or standing backwards in a chair is a fun pose for children. I place a small pillow in the seat of the chair. Then I have the mom place the child in the chair. Finally, I have the mom call the child's name and when she turns, take the photograph.

Prop

I think half of the children in my area under the age of ten have been photographed in this chair. It is the greatest prop I have ever used. It was a rocking chair that I never put the rockers on. It's nice because it is small and the seat tips down in the back. I have photographed children as young as two months in it!

Background

The background is white paper. On the floor is white fur. I don't use fur anymore. It doesn't go white enough. I used to use it because I wanted to save the white paper. Eventually, I found what worked best for me was to paint the concrete floor white. I brought the paper down to the floor at the back of the room and taped it to the floor using clear packing tape. Then once a month I simply repaint the floor where it is getting dirty. One tip I learned from a commercial photographer is to buy your paint in a five gallon bucket. After you paint the floor with a roller, store the roller in the paint, in the bucket. That way, you do not have to clean the roller every time you use it.

Photography

This is an older photograph. One reason I included this image was because it shows the wrong way to light high key. Notice the shadows and dark shading around the chair. I had pointed the background lights too far down on the background. It did not allow for the light to bounce to the foreground. The way I meter the high key background is to have one stop of light more on the background than on the subject. For example, if the light hitting the subject is f-8, the I will adjust the light hitting the background to read f-11 (using the incident light meter for both measurements). I like the lights to be high, even mounted on the ceiling, or on tall light stands. I have found good results if the lights are 2 to 3 feet from the background, pointing down about half way. This way the light hits the paper and bounces toward the floor where the subject is standing. This keeps the floor white around the subject. Even though the lighting is not perfect, it is still a very nice image of a very sweet young lady. The film used was Kodak VPS.

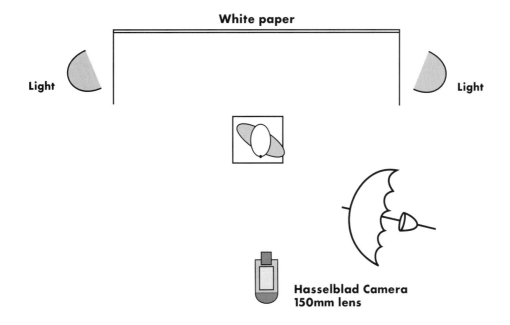

White paper

Light Light

Hasselblad Camera
150mm lens

Almost in School

Pose

I photographed this boy in both a profile pose and this 2/3 face view. Everything stayed the same in both poses except the boy's face was turned a little to the left and the lights were shifted toward the camera. I gave him the pencil and just watched for the right moment.

Prop

The antique desk, stool and thick books gave the feeling of an old time school room. There are two things I could have done to make this image even better. First, I could have straightened the clothes, especially his shirt. The second change I could have made was in the selection of background color. The rule of thumb is is that light colored clothing usually photographs best on a light colored background, and dark colors on a dark background. However, it is still a fun image.

Background

The background was a hand-painted wall in the studio. It has browns, tans and a little blue.

Photography

I used a low camera angle and placed the subject in the lower right hand corner of the photograph. I like to keep children small in the photograph. Look closely at the catch lights in the eyes. They are in the 10 o'clock position. This indicates a proper placement of the studio lights. The film used was Kodak VPS.

Psychology

A good portrait of a child can never be rushed. I like to reserve plenty of time for a child's portrait session. Sometimes I may spend up to twenty minutes just greeting a child and building "trust" before beginning the session. I recommend that parents not schedule the session near other appointments.

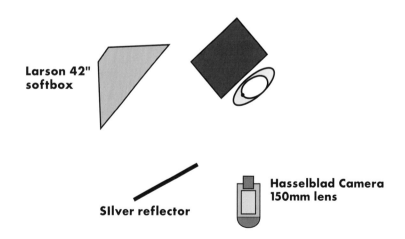

Larson 42" softbox

Silver reflector

Hasselblad Camera
150mm lens

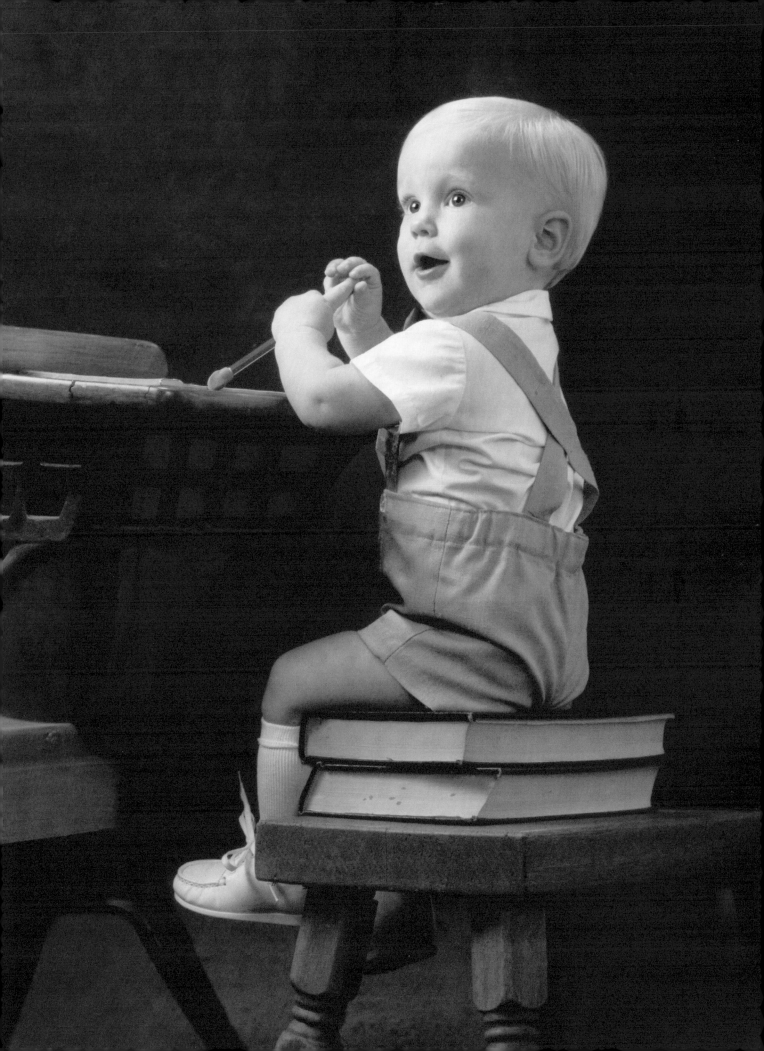

Tough Guys

Pose
Posing brothers together this closely can sometimes be challenging. I usually start with them further apart and slowly, as the session proceeds, bring them together. The slight tilt of their heads give a feeling of caring and closeness. These little guys may not care for each other right now, but some day they will.

Props
The jean jackets with no shirts make for a simple photograph. This focuses all of the attention on the faces.

Background
The background is a grey blotchy muslin background from Les Brant (see the suppliers' list in the back of this book). I placed it about eight feet behind the boys to throw it out of focus.

Photography
The lighting is a modified butterfly lighting (butterfly lighting is achieved by placing the light over the camera, with the light placed between the camera and the subject). The lights used were Photogenic Flash Masters. They are resonably priced and very versatile. I've had them for almost fifteen years with almost no problems. The Larson 42" soft box was placed above and to the left of the camera. The reflector is placed low and to the right of the camera. Then I tilted the reflector back and forth to visually fill in the shadow area. A hair light, high and to the right, along with a background light separates the subjects from the background. I used a Coken 083 soft focus filter, held in front of the lens. Exposure was 1/60 second at f-8, and the film used was Kodak T-Max, rated at 200.

Psychology
The two brothers were in a good mood. However, if siblings don't want to cooperate, I quickly get their minds off the photography session. We talk about things they like to do: sports, fishing, school, or anything that gets their minds off what we are doing.

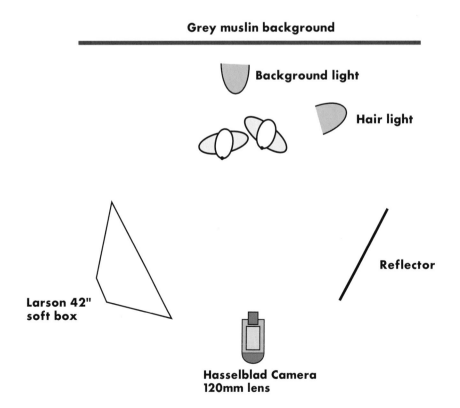

Grey muslin background

Background light

Hair light

Reflector

Larson 42" soft box

Hasselblad Camera 120mm lens

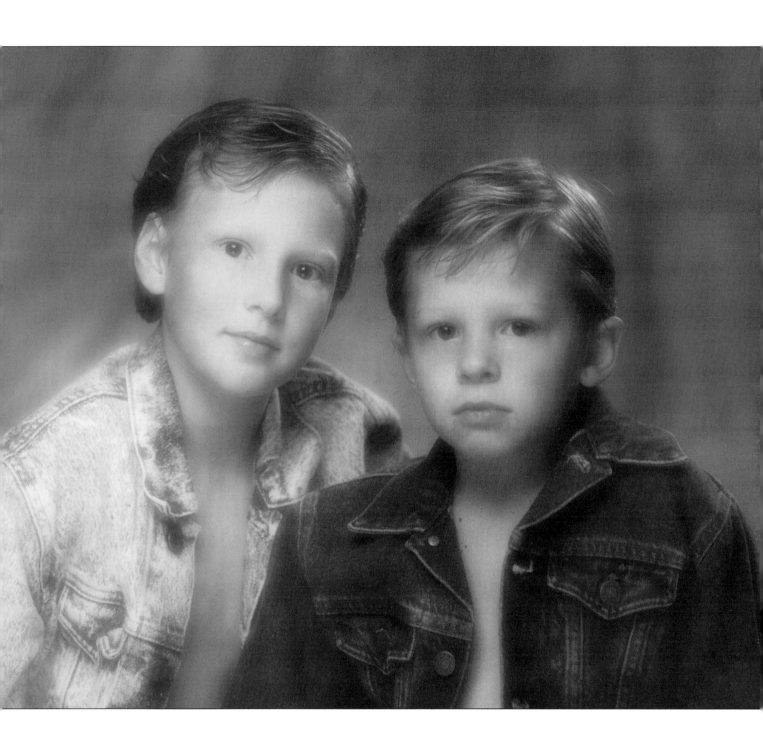

Spelling Blocks

Pose

A fun pose for a small child who is just learning to sit up is with these spelling blocks. We spell the child's name with the blocks in front them. The only problem with Eric is he would pick up the blocks as soon as we put them down. It is still a cute image!

Photography

A single light passing through an umbrella is the light source for this image. The light is to the left of the camera, placed in front of the boy, turned slightly toward him, with the center of the light 6-8 inches above the child, pointing slightly downward. The film used was Kodak TRI-X, exposure was 1/60 second at *f*-8.

Background

The background is a grey blotchy muslin. I placed it about eight feet behind the boy to throw it out of focus.

Psychology

Be ready! Many times when photographing children, you only get one chance at a great image, and sometimes that one chance only lasts a second or two. Always set up the camera, lights and even pre-focus, because opportunities for a great shot may pass quickly!

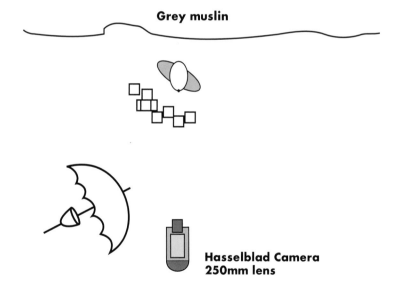

Grey muslin

**Hasselblad Camera
250mm lens**

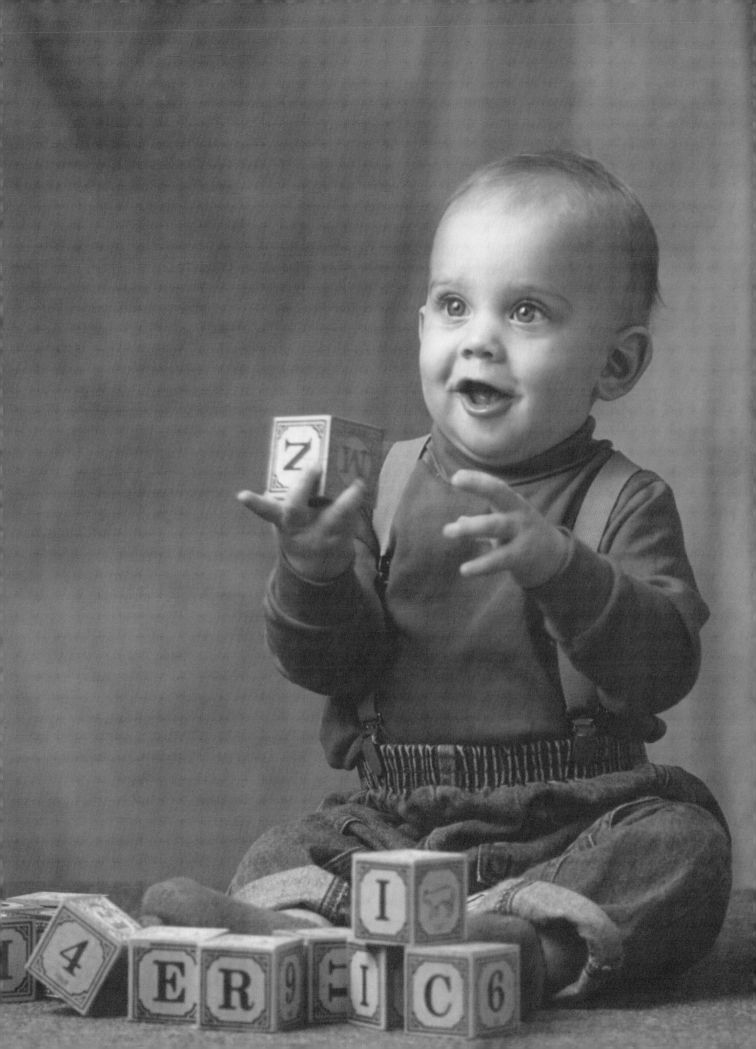

Outdoors and on Location

Children are much more intelligent than people give them credit for. Let them be involved in the process by telling them what you need them to do and how long it will take. Ask their opinion on how they would like to be photographed – you'll be surprised at the answers!

Father and Son Fishing

Pose

There wasn't much posing going on here! I just let the dad and his son fish. I have presented two different versions of this image. One (this page) has vertical composition and one has horizontal (next page). The horizontal image is also soft focus. You decide which one you enjoy most.

Props

Matching outfits and hats. Simple but effective. Try to imagine this image with distracting clothing.

Psychology

You really don't have to do much direction. Most dads would probably enjoy spending this kind of quality time with their sons.

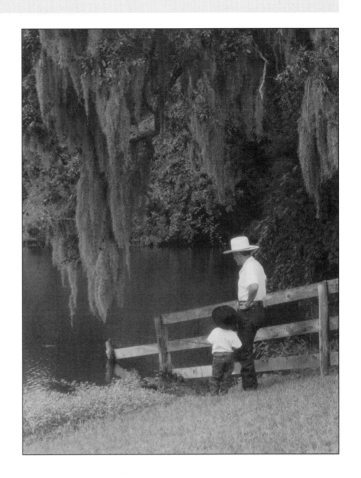

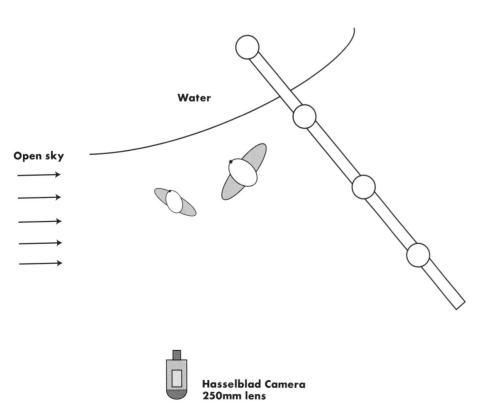

Water

Open sky

Hasselblad Camera
250mm lens

Photography

I like the horizontal composition best. In the vertical composition, there is a lot of space above and below the subjects. I've always been told if a part of the image is not working for you, it is working against you. In this example I feel the horizontal composition directs your eye to the subjects better. I also like the interaction between the subjects in this photograph. The soft focus is created with a Coken 083 filter. My only problem with this filter is that it tends to flair white clothing. It did so in this image but it is not too objectionable. The film used was Kodak PPF, the exposure was 1/60 second at f-5.6

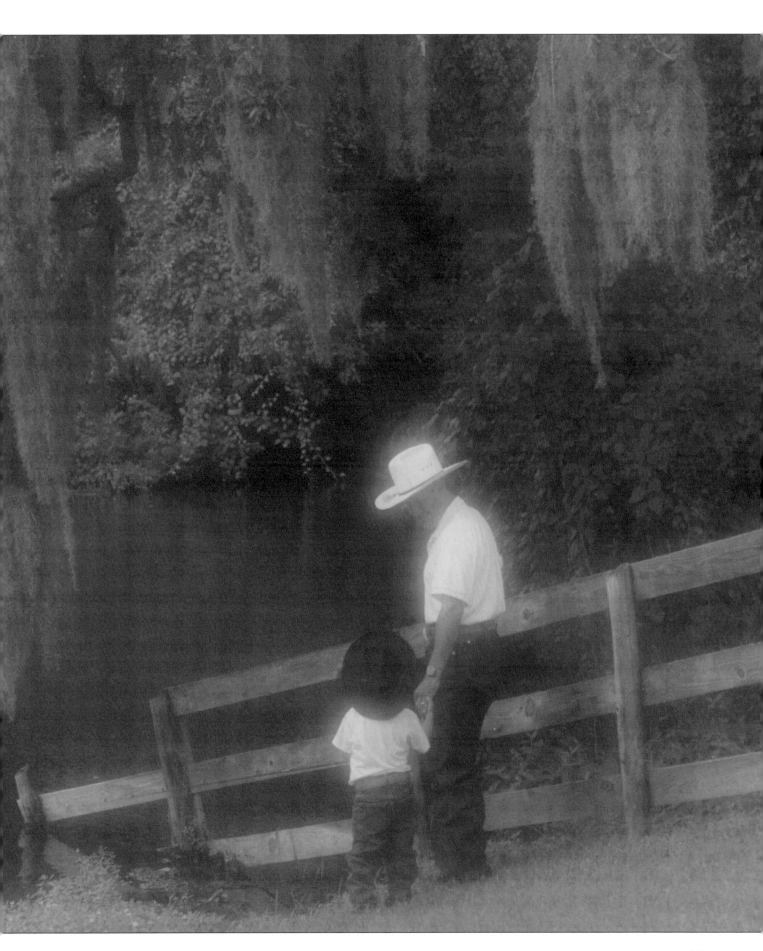

Peter Rabbit's Garden

Pose

What could be simpler? Sit a small child down and lean him against an overturned wash tub. Notice the bare feet. Little children's toes are always cute in a photograph. What do you do with little hands? Give them something to hold – but keep mom close because everything goes in the mouth.

Props

The cute little hat is really the only prop in this image. Everything else is part of the background. Thank goodness some children smile easily. This little boy does and does it well. I was glad, because the mom wanted to show off both of those teeth!

Background

Our herb garden is built next to a storage building. Included in the set are the wash tub, old watering can, some real herbs, some silk sunflowers, an old wash board, a couple of clay pots and the sign. The back wall is old barn wood.

Photography

This was taken before I installed a tin roof over the set. Without the roof, the light came too much from the top. Looking at little boy's arms, you can see the light. Shortly after this I installed the roof. It comes out about eight feet from the back wall. Incident meters have two options: a half round dome and a flat disc. I prefer the flat disc as it gives me more accurate exposures. This is a great example of using the flat disk. Because of the strong top light, the dome would have also read the light from above, giving the wrong meter reading. The results would have been under exposure. It is very important to test your equipment, film and metering techniques. Consistency is very important. When I use the flat disk, I always point it straight at the camera to ensure consistent results. Exposure was 1/60 second at f-5.6, the film used was Kodak PPF .

Psychology

Not much psychology was needed with this happy little fellow. A simple game of patty-cake was all that it took to get this great expression and pose.

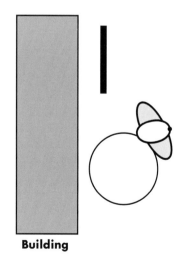

Building

Western light

**Hasselblad Camera
250mm lens**

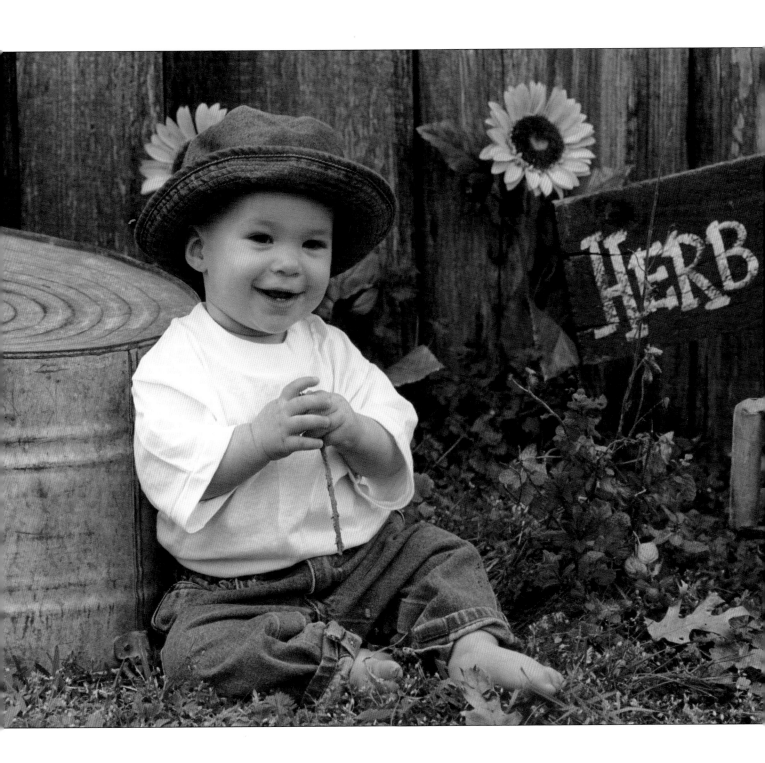

Mother and Daughter

Pose

This was one of the first Heirloom Portraits I did. This is a very natural pose for a small child and her mom. I turned the mom toward the window light and sat the small girl on the mom's lap.

Prop

This was done on location at their house. This always adds a personal touch to the photographs. The dresses and the furniture are theirs.

Versions

Pages 42 and 43 show two alternate presentations of the same basic image. The first is a sepia print mounted on brown paper. The paper was hand torn and mounted with spray adhesive on an off-white art board. I wanted to create the illusion of a print torn from a scrap book, then mounted and framed. The other image is a simple black and white.

Photography

This was the breakfast room at their house. There were windows on two sides of the room. The window to the right of the camera provides the illumination for the image. I brought a silver reflector in from the left side. When I first arrived the sun was shining in on the area where the furniture is sitting. I put a translucent scrim outside up against the window to soften the sunlight. A few minutes later the sun moved on so I did not need the scrim for this image. The film used was Kodak TXP rated at 200.

Heirloom Portraits

Heirloom Portraits are old-fashioned, black and white images hand printed on Kodak Ektachrome G fiber based paper. I use the fiber base paper for authenticity and archival quality. Some of the images are hand tinted with pastel chalks, then coated with photographic lacquer.

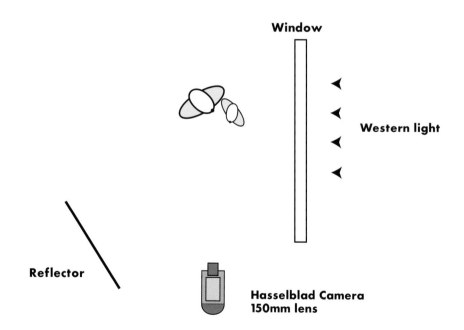

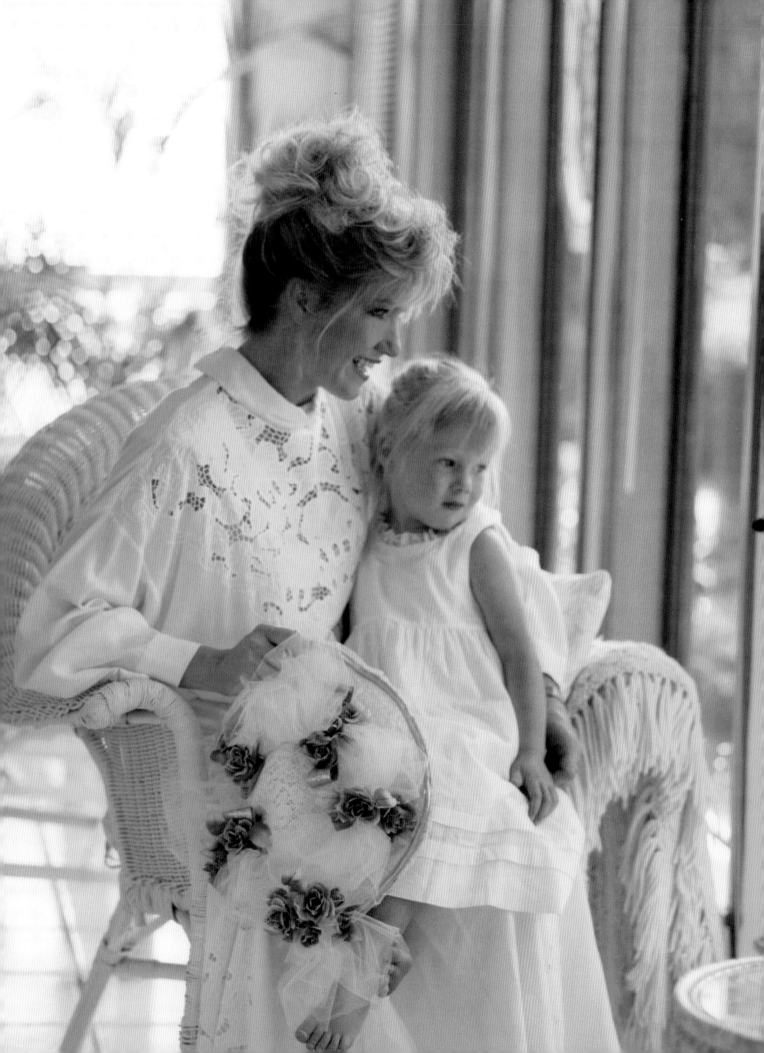

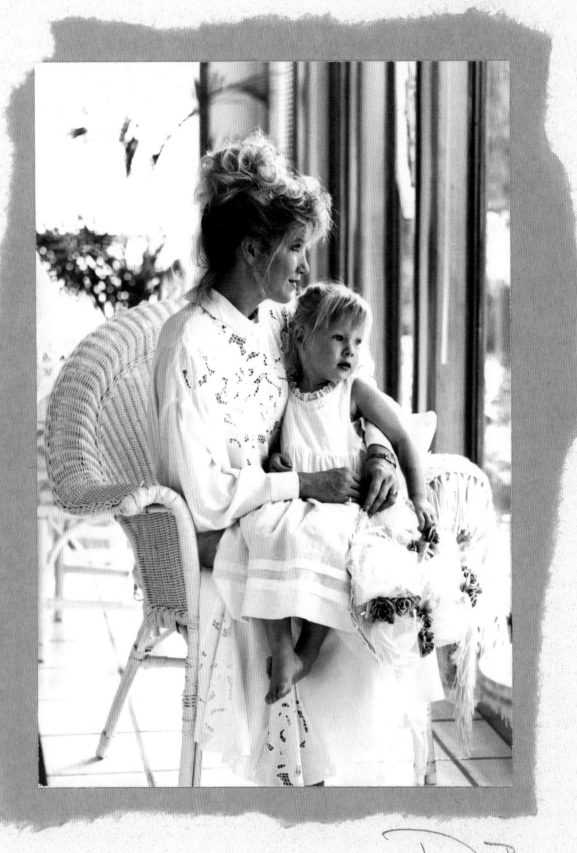

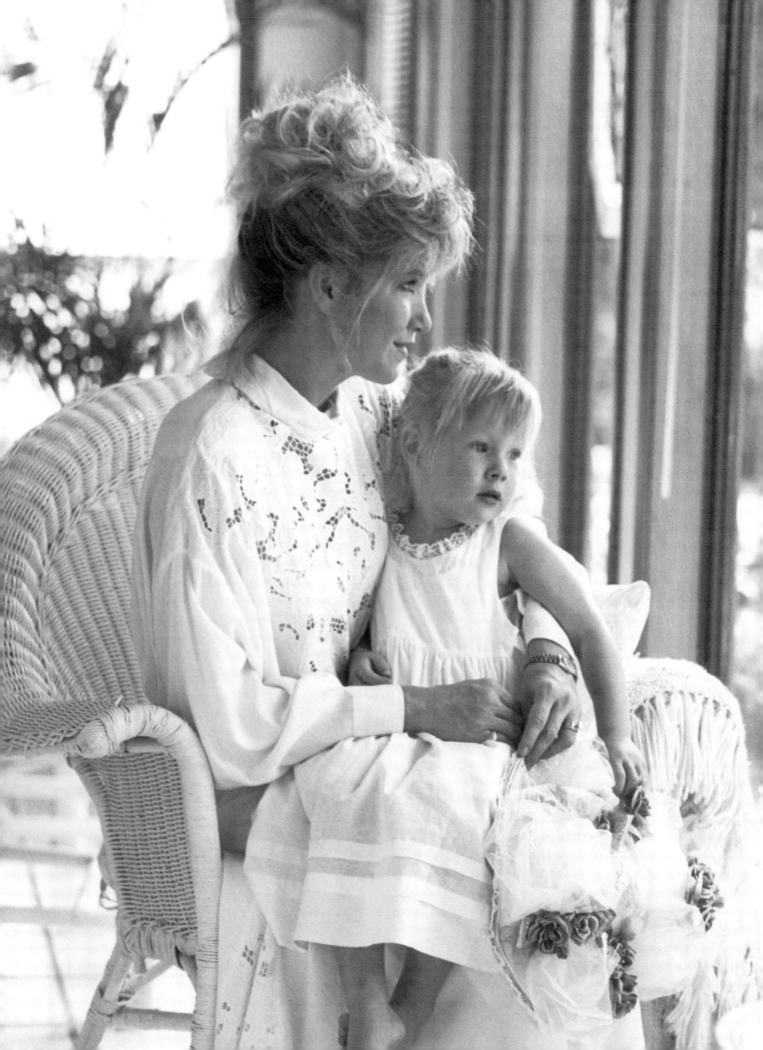

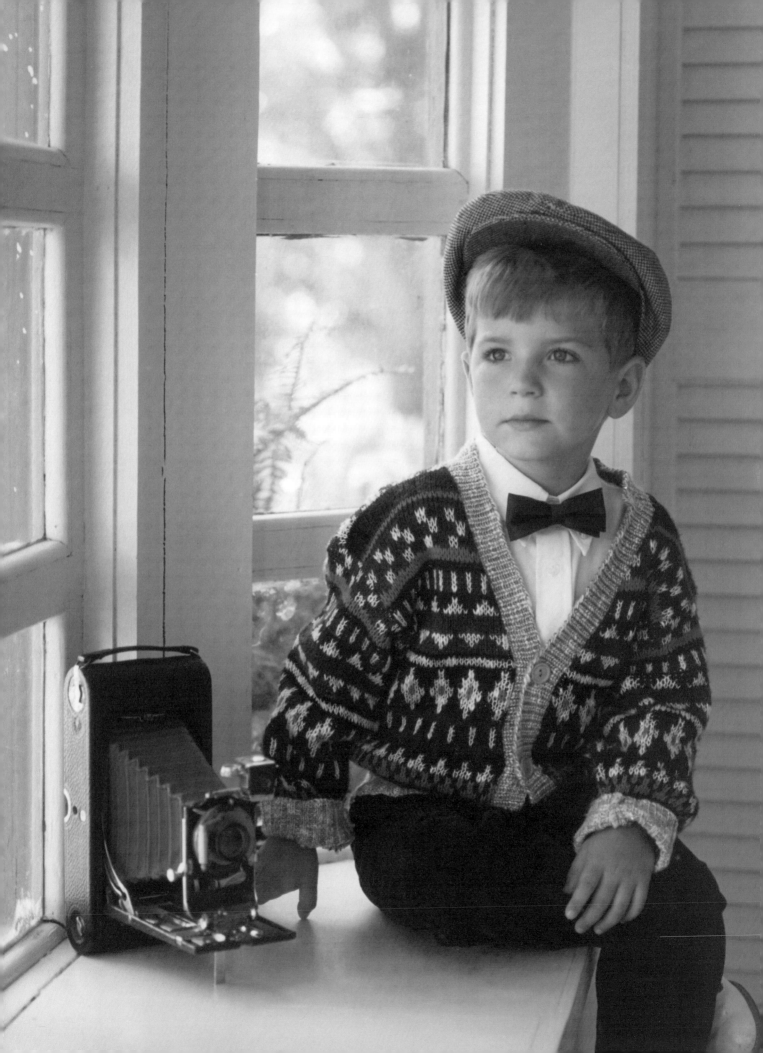

Littlest Photographer

Pose
One of my favorite sitting poses for children is to tuck one of their legs under the other leg. Shoulders are turned slightly away from the window, face turned a little toward the window. Eyes are centered in the eye sockets. The rule is 'The eyes follow the nose.' Give the subject something to look at, then turn the face to center the eyes in their sockets. Typically, when people look away from the camera, the eyes look further than the direction of the face. This leaves too much white of the eye showing.

Prop
The antique camera seemed to compliment the little boy's hat, bow tie and sweater. Keep props from dominating the photograph.

Background
This is a window seat built into the north wall of the camera room. It is painted egg shell in color. Althogh this image happens to have been shot at a window in the studio, the look would also work on location.Behind the young man is a pair of shutters. They are 18" x 72" each. They are hinged together and are movable. They are egg shell on one side, and white on the other. This makes the set twice as usable.

Photography
I used the 120mm lens because of its shorter focal length. The room is not very wide. To meter, place the meter near the boy's face, pointed directly at the camera. Exposure was 1/60 second at f-5.6, the film used was Kodak VPS.

Psychology
I find that children will mimic your demeanor. If I want a soft, quiet mood for the image, I act, move and speak in soft, quiet tones. Or if I want a quiet child to perk up and have more expression and big smiles, I get a little louder, smile and laugh a lot. I even play silly games with the child.

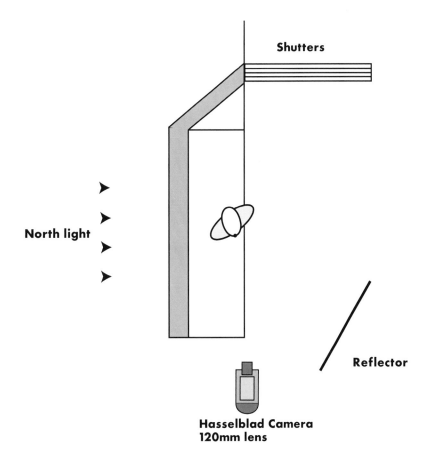

Shutters

North light

Reflector

Hasselblad Camera
120mm lens

Sharing

Pose

I love the innocence of these two children sharing the joy of playing with the flower. Their mother asked the boy to show the flower to his sister. You have to be ready and react fast with small children, especially with two small children. This is where the extra speed of the PPF film comes in handy.

Prop

The mom did a great job of picking out the outfits. The matching white shorts set is great for this outdoor area.

Background

The background is done with potted plants. The concrete garden bench is sitting on the porch. The plants are in five gallon pots.

Photography

The 250mm lens allows me to be far enough away from the children to remove me from their con-sciousness. They aren't even aware I am here. As you can tell by the background, this was not taken at prime time for outdoor portraits. Because I have to take photographs at almost every time of the day, I built this posing area. The area is shaded in the afternoon by the building. The plants in the shade block most of the bright areas in the background. Exposure was 1/60 at *f*-5.6, and the film used was film Kodak PPF.

Psychology

With shy children, many times I am completely quiet and let the parent work with and direct the children. This is a perfect reason for using the long lens. I can almost "hide" behind the camera and by not saying anything, the children will forget I am there and begin to act normally. Listen to the parents about the mood and disposition of the children. As a man, I find children are more likely to be afraid of me. This is where women and parents have an advantage.

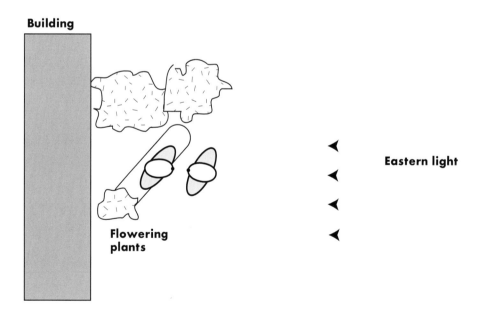

Building

Flowering plants

Eastern light

Hasselblad Camera 250mm lens

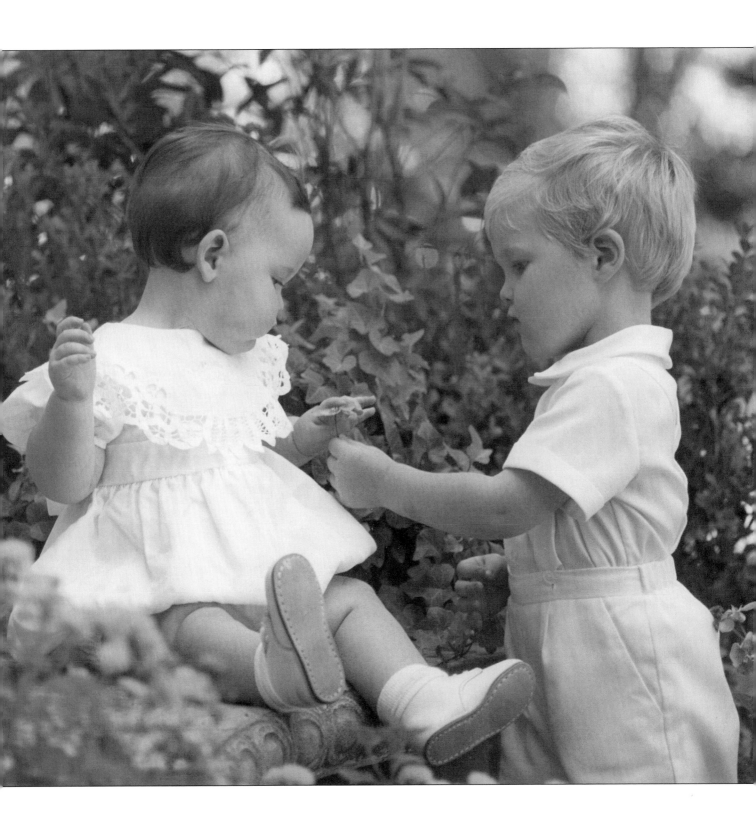

Hook, Line and Sinker

Pose

This little boy is posed on a bridge. See how cute hats can be? As you probably can tell, he is about to take the hat off. But it looks like he has just put it on.

Props

The hat and fishing pole are popular props for small boys. So are overalls. I have a collection of these in several sizes. Every once in a while, no matter how much talking you do about clothing, sometimes moms will bring an outfit with a huge cartoon character on the front. I take a few images in that outfit, then tell mom of this great idea I have with a fishing pole and hat, does she have a pair of overalls with her? No, that's okay, I just happen to have a pair that will fit. Whew, I dodged that one!

Photography

Simple lighting, nothing special here. Just straight forward meter and expose. I do like the little scowl on his face. Kids don't always have to smile. The film used was Kodak VPH. The image was shot at 1/60 second at f-8.

Psychology

Photographing children can be fun, if you know the secrets. It can also be demanding. I will admit that it does help to be a "child at heart." You should enjoy playing games and pretending. You should enjoy sitting on the floor and crawling on your hands and knees. You should enjoy being silly and laughing a lot. If you don't enjoy all of these things, that's okay, just get someone to work with you that does. Then you can "hide" behind the camera, be quiet, and take the photographs.

North light

**Hasselblad Camera
250mm lens**

Wooden bridge

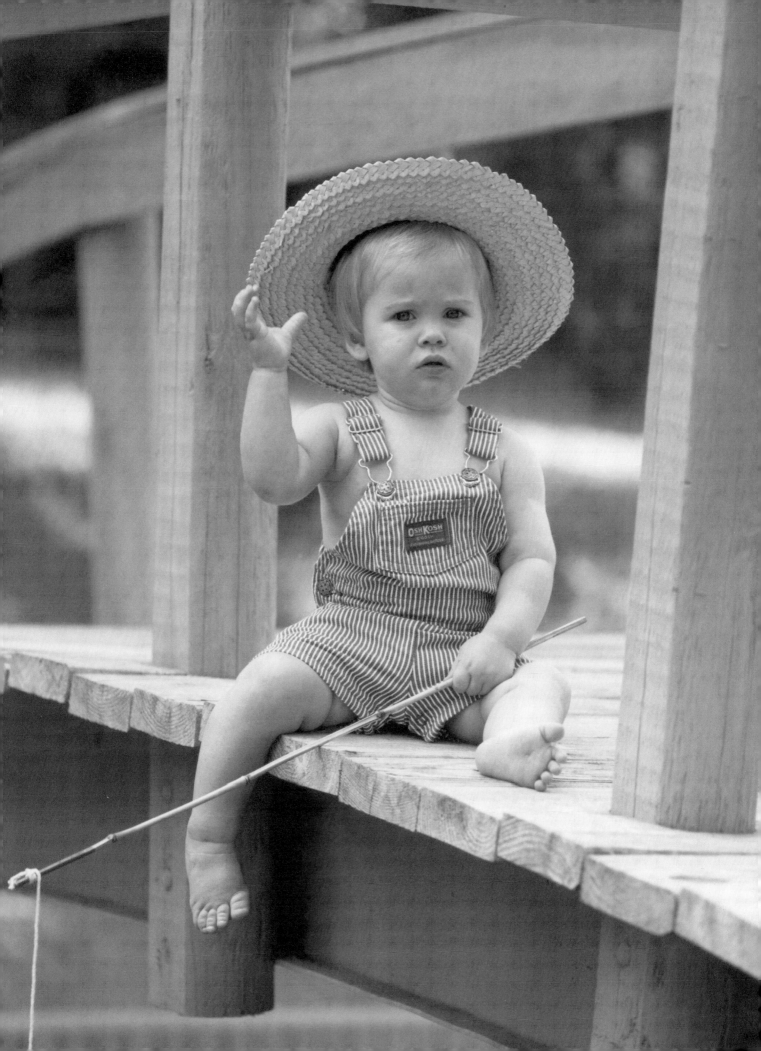

Anyone Home?

Pose

The pose is natural. In fact, she did it herself. I set the mood for her (see Psychology below) and then let her do her own thing. This is a great way to get natural poses of children. Some people will say, "But you can't see her face!" That would only be a relevant comment if you have no other photographs of this little girl. But that is not the case. We have lots of photographs of her face. This is a photograph of her soul, her personality, even her individualism. I like it very much!

Props

The porch is the prop, along with the door bell and the bare feet. The porch is on a beautifully restored home in town. The door brings your attention to the center of the image and the natural action of the young lady keeps your eye there, on the subject. You wonder what she is doing. You wonder who lives there. You wonder what she is thinking.

Photography

Photographically this is simple. Nothing was used but a camera, tripod and a light meter. When using an incident light meter, put the meter at the subject and point the meter directly at the camera. I use a tripod on most of my portraits to increase sharpness in the final image. The film used was Kodak PPF. The exposure was made at 1/60 second at f-5.6.

Psychology

Since children love to play make believe, I use this fact in my favor. "I wonder if anyone is home?" I ask inquisitively, with fun in my voice. "Why don't you ring the door bell and see if anyone comes to the door." I got a series of images during this session. This was my favorite. I think it shows the inquisitiveness of children. I love the little bare feet, standing on her tip toes and showing her independence by reaching way up, doing it her self!

**Hasselblad Camera
150mm lens**

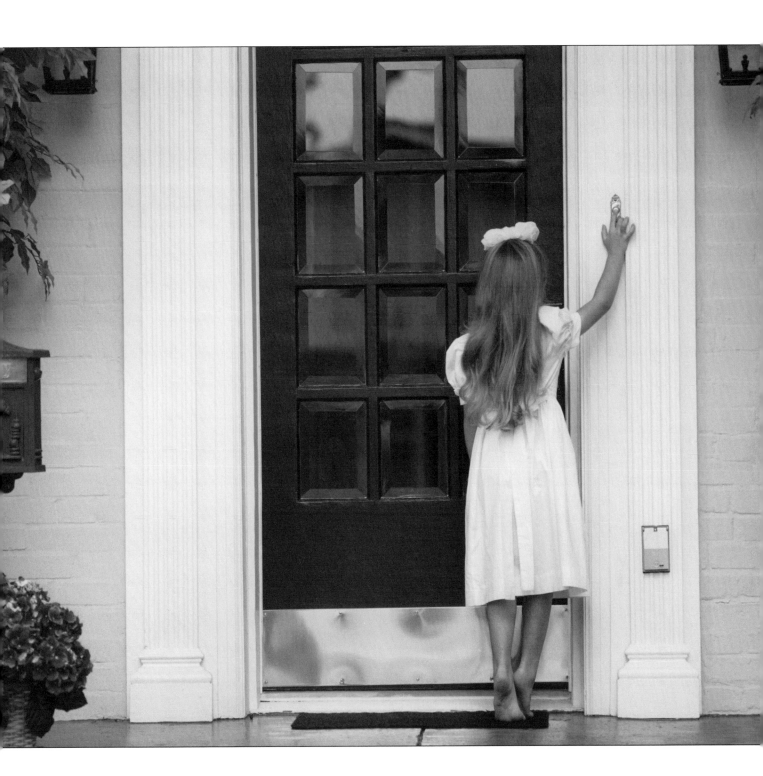

English Riding Student

Pose

I find the little things make a big difference. The leg is bent, the face is turned so that you can see both eyes, but the far eye is contained inside the line of the face. The same thing applies to the nose. The end of the nose does not protrude past the edge of the face. I also like the gentle way the boy is holding the reins.

Props

The riding outfit and the horse are the props. The little outfit makes the image seem more formal.

Photography

The only thing that would have made this image better is if I would have used a longer lens, like the 250mm. Notice the bright sky in the upper right hand corner. It is a little distracting. You can crop it out by taking off the top quarter of the image. However, I like the space above the boy which gives him scale. It shows his small stature, especially with the big animal. The 250mm lens has a smaller angle of view. That is effective for keeping the sky out of photograph. The hard part was to find just the right spot so that I would have a little of the soft direct sunlight hitting on the boy, but not washing out the foreground. The film used was Kodak PPF. The image was shot at 1/60 second and f-5.6

Psychology

When I want a soft expression, I speak in soft tones. This causes the child to also speak softly and even calms the animal.

Direct, early morning sunlight has a low angle and is not as bright as later in the day.

Open Sky

Hasselblad Camera 150mm lens

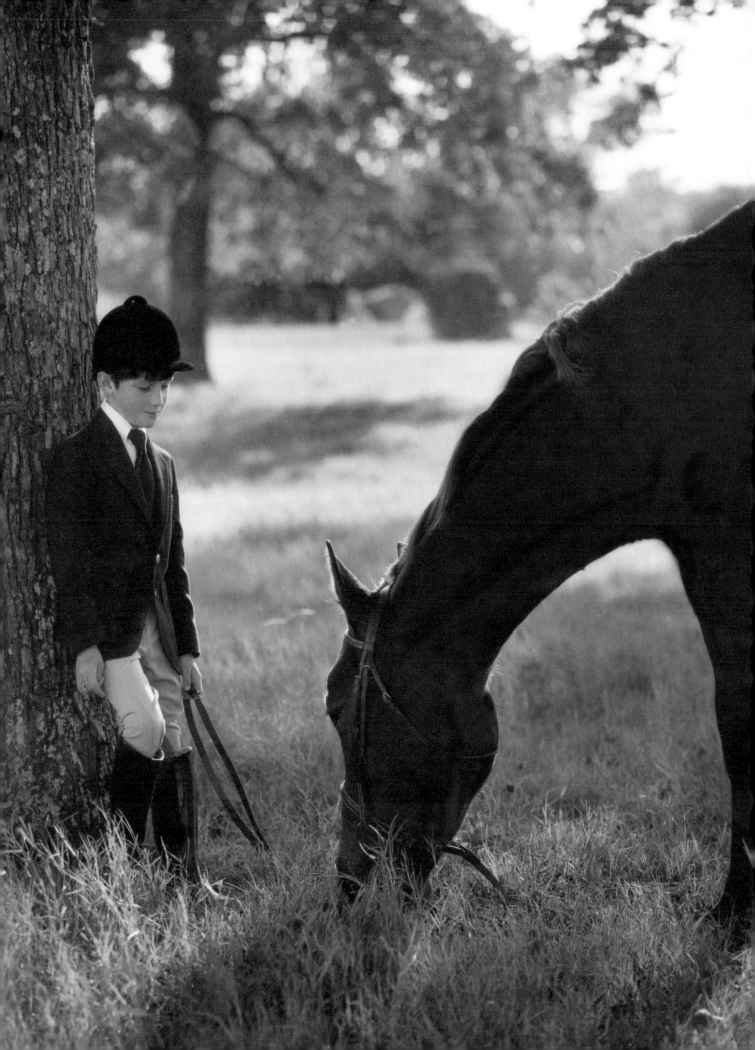

Grandpa's Girl

Pose

I had the girls put their weight on their inside feet (the feet closest to each other) and brought the other foot out slightly, to form a modified C pose. The younger the child, the harder it is for them to hold this pose for long. This is especially true when they have to hold hands with each other and hold an umbrella at the same time.

Prop

I love when children dress alike. This way the clothes don't take attention away from the girls. The mom had the umbrellas. They may be a little dark for my tastes, but I felt they did match the dresses and added a nice touch.

Background

This was photographed at Grandpa's house. The place was important, so I chose the 150 mm lens to let more detail in the trees and the moss show. If I had chosen the 250 mm, the background would have been more out of focus.

Photography

Notice the direction of light on the girls' faces. You must look for open sky for a light source. This was taken mid-morning. Lucky for me there was good cloud cover. This kept the sun from making hot spots on the ground and in the background.

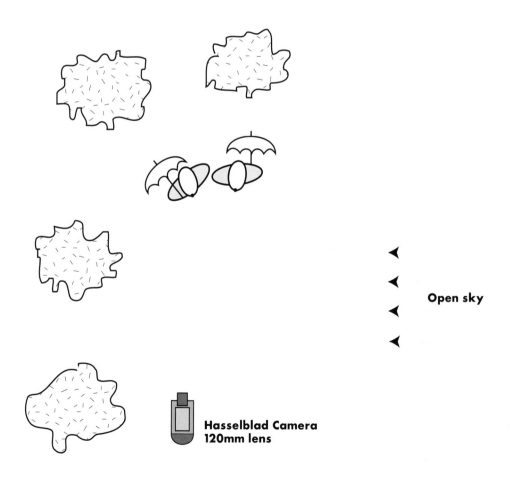

Open sky

Hasselblad Camera
120mm lens

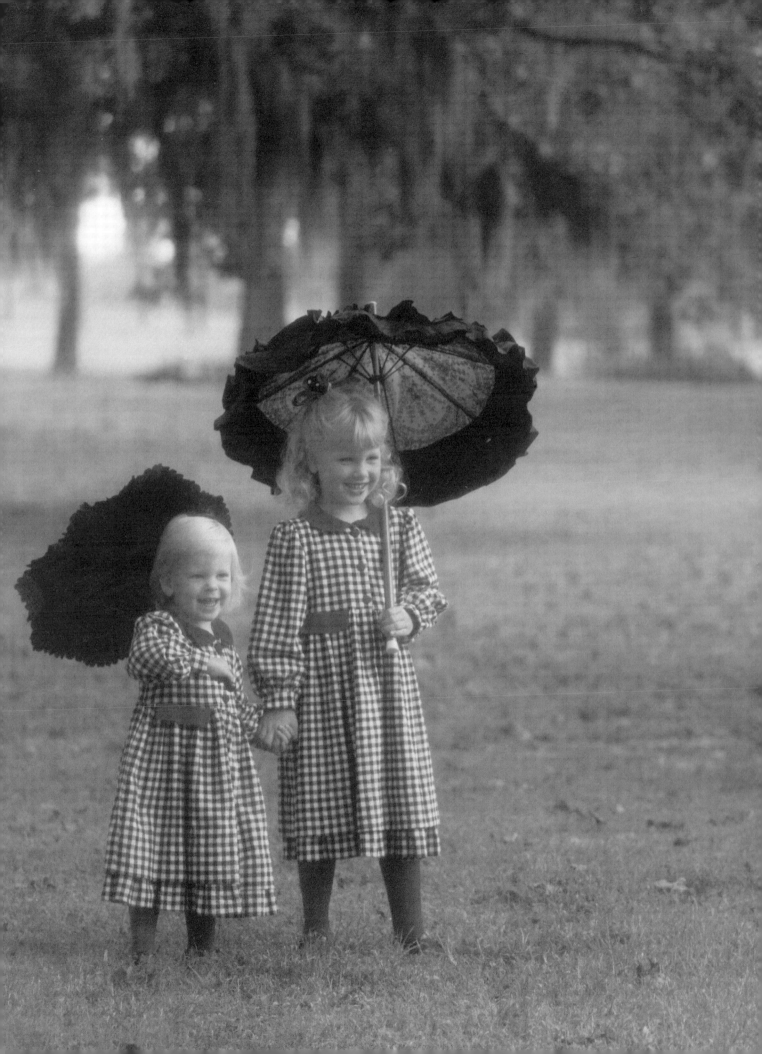

I Christen Thee

Pose
The image was taken on a day after the actual baptism. That allowed me to bring lights into the church to make the image. The mother is holding the baby the way she did during the ceremony. The pastor was scheduled to meet us for the session. At the last minute, he cancelled due to sickness. So, I had to stand in as the hand as well as photographer. I had to use a long air release to trigger the camera. The grandmother advanced the camera between exposures. Sometimes you have to make the best of a bad situation.

Props
The props are the baptism font, the stained glass window, the water and my hand.

Photography
The lighting is a Photogenic Portamaster, bounced out of an umbrella to give the overhead light, and another umbrella at the camera, off to the right a little, to provide "fill." This lights the side of the subject facing the camera. The hard part is balancing the two light heads and the sunlight coming through the stained glass window. You will notice some of the light from the umbrella providing back light is bouncing out of the bowl providing even more roundness to her face. I used the shutter speed to control the brightness of the window. A slower shutter speed would have made the window brighter in the photograph. In turn, a faster speed would have resulted in a darker window. The 1/60 second exposure at ƒ-8 provided just the right amount of illumination.

Camera
One of the great things about the Hasselblad is an optional Polaroid film back. Switching to this back allows you to test the lights and camera. This is especially important when you are mixing light sources, such as in this image.

Psychology
The main psychology was convincing the mother that everything was going to be all right, even though the pastor was not there and I had to use my hand to place the water. This type of image became quite popular for my studio. The image created a lot of interest and several subsequent sessions with other clients.

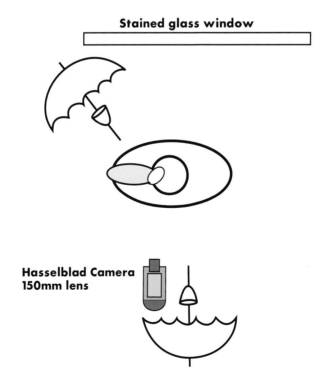

Stained glass window

**Hasselblad Camera
150mm lens**

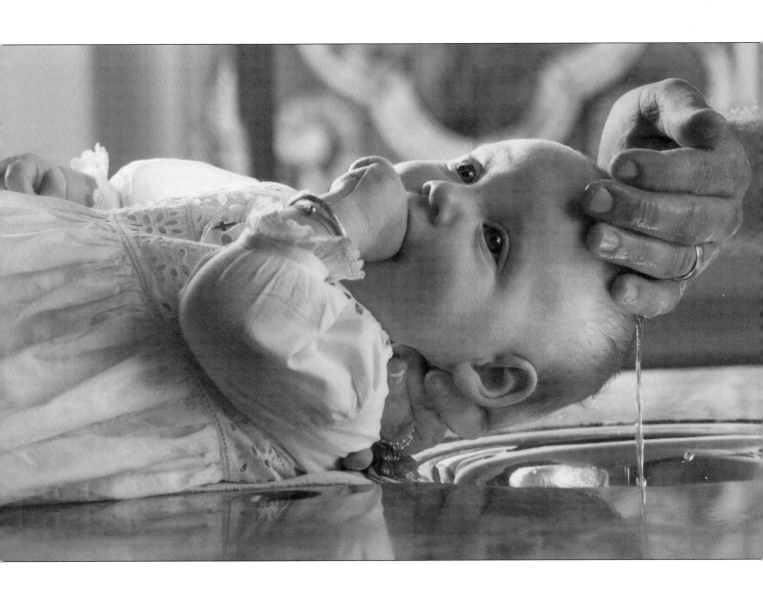

Against the Column

Pose

I like when little boys put their hands in their pockets. That way I don't have to worry about what they are doing with their hands. Look how a little thing like crossing one foot over the other changes the whole image.

Props

The column was in the entryway of his home. Still, it's the outfit that is really the prop. The classical "little boy" outfit is, to me, what makes you stop and look at the image. The simplicity of the clothing, along with the elegant and somewhat simple background, adds to the feeling of the portrait. To me it has an elegant, innocent and fun feeling for a portrait of a very nice little boy. Try to imagine him in dark pants with a multi-colored striped shirt – it just wouldn't be the same! This is why I think that clothing is so important.

Photography

The lighting is very simple: a Photogenic Power Light, one umbrella and a silver reflector. I shot out of the umbrella to get a harder look to the light (notice the shadow from the boy on the column). I used a slow shutter speed to keep the background from going too dark. The photographic jargon for this would be, "I dragged the shutter to open up the background." Basically, what this means is using the ambient light in the room to light the background. A faster shutter speed would cause the background to record quite a bit darker. In fact if I would have used 1/500 second, the background would have recorded almost black. By balancing the ambient light with the flash exposure, I was able to show the stairs, but not let them overpower the portrait. Notice that I also moved the camera so as to position the boy's head in an area of the background that is plain. If the camera position was to the left, the boy's head would have merged with the busy pattern of the stairs. I think that would have been distracting. The film used was Kodak VPS. The exposure was 1/15 second at f-8.

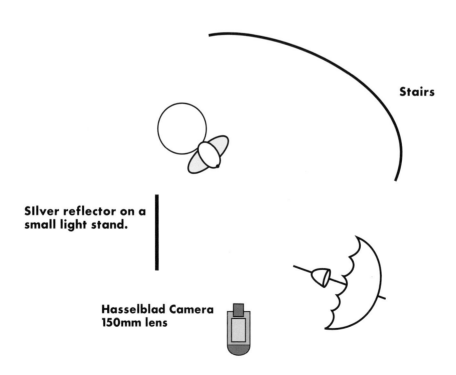

Stairs

Silver reflector on a small light stand.

Hasselblad Camera 150mm lens

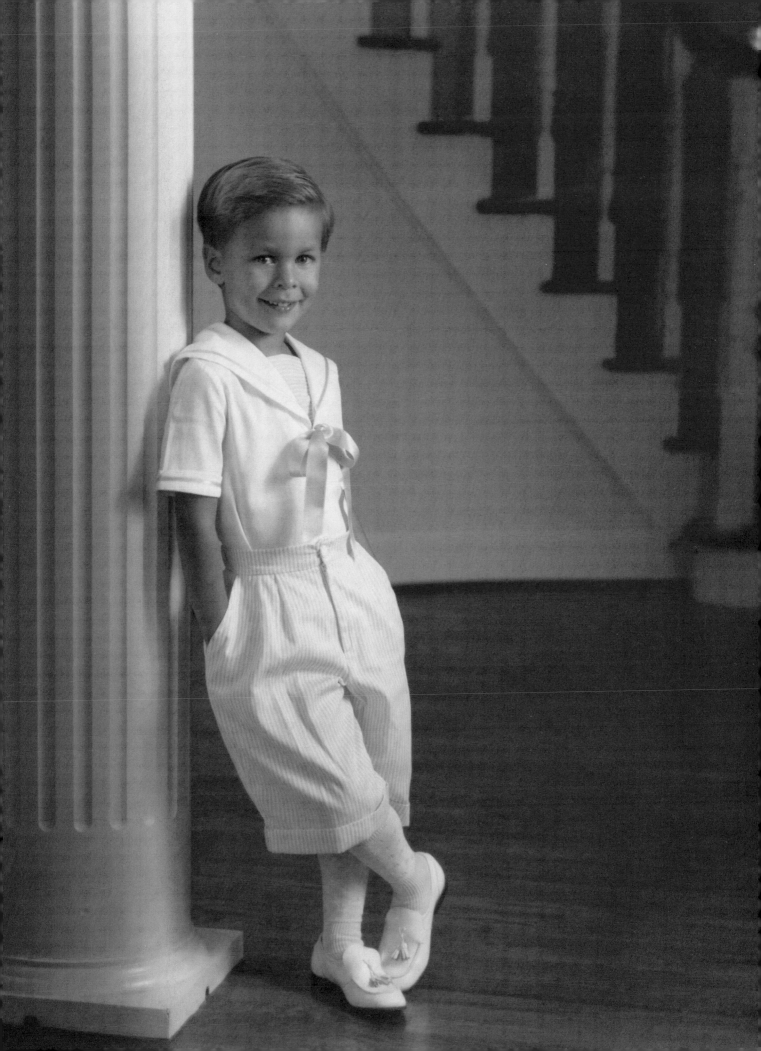

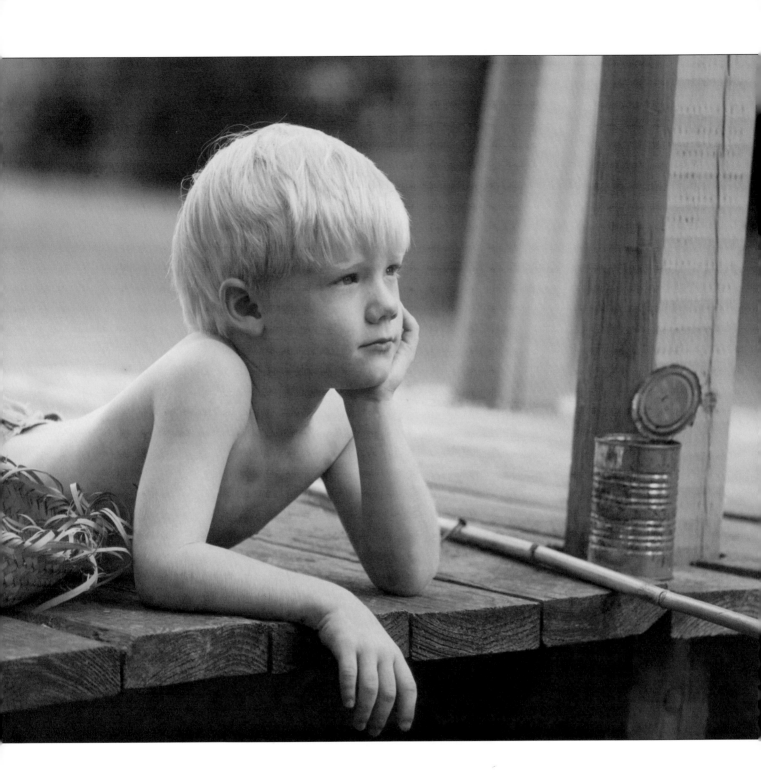

Gone Fishin'

Pose

The young boy is in a simple "on the tummy" pose with his chin resting on one hand. This is a natural pose for little boys. I usually act out the pose for the child so they can mimic my action rather than relying on my direction.

Props

The innocence of no shirt with blue jeans, combined with the cane pole, worm can and straw hat, were just right for this cute blond boy. He seems to have just a touch of mischief mixed with wonderment in his eyes.

Background

This bridge, which is at the studio, is a popular place to photograph all kinds of subjects. It spans a usually dry water crossing and is about twenty feet long. The base is made of two curved steel beams. I used landscape timbers and 2"x6" lumber for the rest of the bridge.

Photography

The 250mm lens isolates the young boy against the trees in the background. Place the meter near the child's face, pointed directly at the camera. I use the flat disk on the Minolta IIIf meter. Exposure was 1/60 second at f-5.6, the film was Kodak PPF. Since most of my outdoor photographs are made in open shade, the Kodak PPF film is perfect. It has great color saturation and a slightly higher contrast than VPS. The added contrast adds to the direction of light in these subtle lighting situations.

Psychology

Children love playing "make believe" and so do I. Once I got the camera all set up, I talked to this little guy about fishing. He loved to fish. I said to him, "Just imagine you are by your favorite fishing hole, the sun is shining, you can even see some big fish jumping!" You can almost see just what he is thinking about in his eyes.

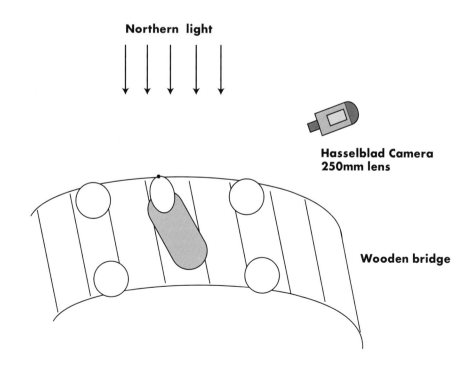

Northern light

**Hasselblad Camera
250mm lens**

Wooden bridge

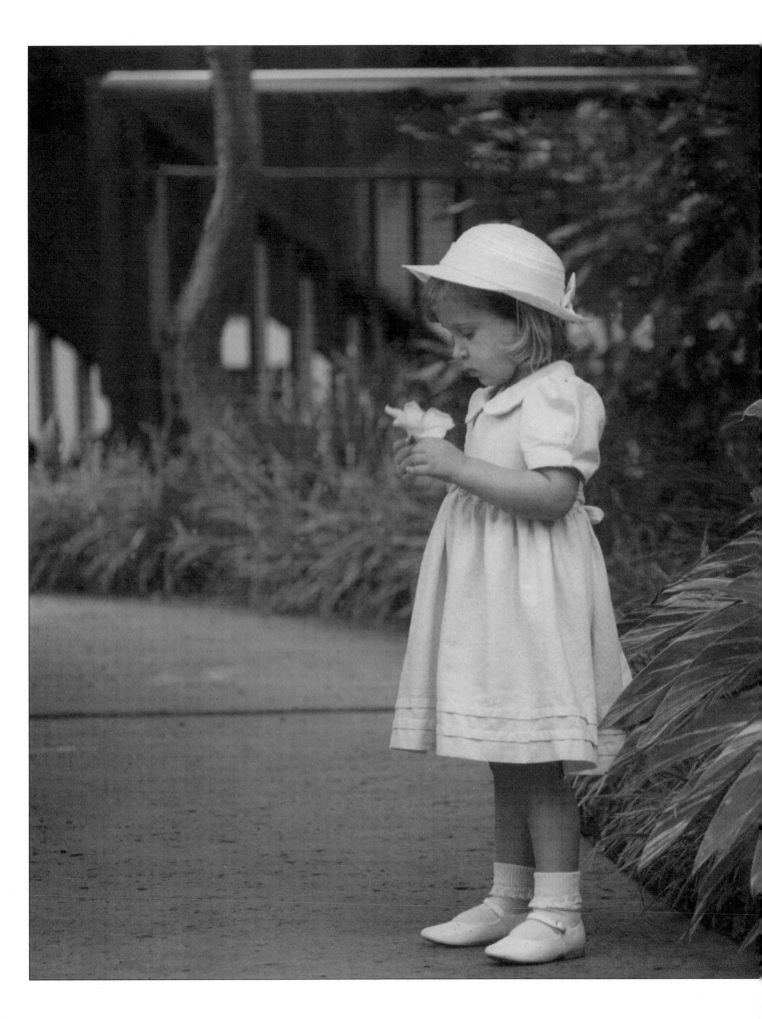

Flower Child

Pose

The pose is very natural: standing, holding the flower and looking at it. It is simple, easy and innocent. You don't always need complicated poses to create a great image.

Props

The flower was growing in the area. It was used to take her mind off me and the fact that we wanted to take her photograph.

Photography

This photo was taken on the family vacation. This is a great time to do photographs since the family will be in some new and exciting places. The background was just a hedge of bushes. The light was coming from the left and from above. By having her look down we keep top light from being a problem.

If the light comes from too high an angle, the natural shading from the eyebrows and forehead can cause the eyes to record darker. I call that "racoon eyes." The film used was Kodak VPH. The exposure was 1/60 second at f-8.

Psychology

This young lady did not want to have her photograph taken. We had done her family's photograph earlier and she was about "photographed out." We took her to another area of the hotel grounds and tried to get her not to think about being photographed. I let her mom handle her, give her the flower and do all the talking to her. I find that the less you talk about taking pictures and the more you talk about having fun, the better results.

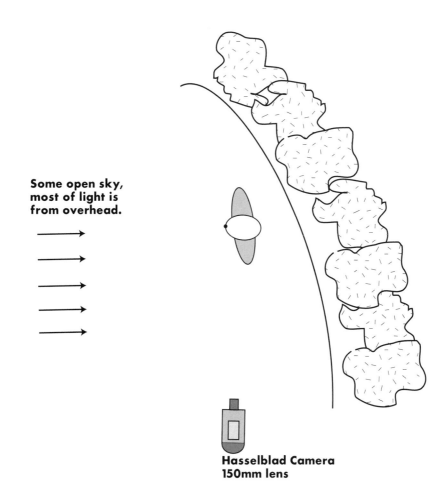

Some open sky, most of light is from overhead.

Hasselblad Camera 150mm lens

Little Gardener

Pose

I turned the young lady away from me for two reasons. I wanted a profile, and I did not want to distract her. I had her mom stand in a position so that when the girl looked up at mom, I would get a profile.

Props

I placed the water can on the upside down wash tub. It seemed to go perfectly with the old wood of the shed, her outfit, and especially her hat.

Background

I used the 250mm lens to throw the simple grass background out of focus. It also kept the swing set which was just out of lens range from showing.

Photography

The 250mm lens also isolates the young girl against the background. Look at the nice lighting on her face. The open sky provides the illumination. The building to the left blocks the light from the left which gives direction to the light. The exposure was 1/60 second at f-5.6, the film used was Kodak T-Max 400 CN – a great new product! This film is processed in color chemistry but prints can be printed in a range of tones from a subtle blue tone to black and white to sepia tone. I chose this film for the nice sepia tone it can give. If you like to shoot black and white, but don't like the hassle of processing yourself, or the expense of having the lab process it (black and white usually costs 20-40% more than color processing), this film is for you!

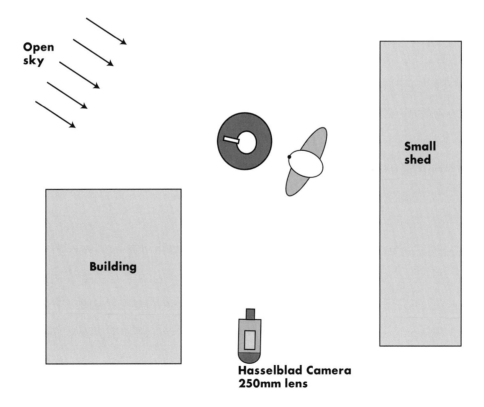

Open sky

Building

Small shed

Hasselblad Camera
250mm lens

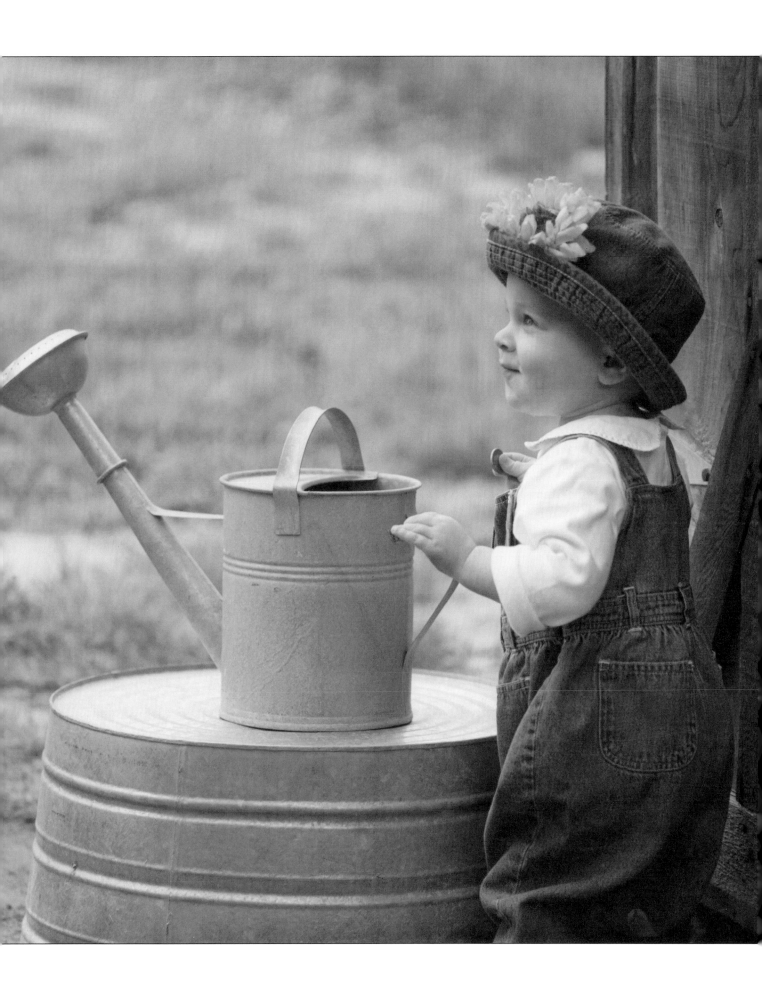

Seashore Discovery

Pose

With some children the best way to get a natural pose is simply to talk to them. We were talking about all of the things that are at the seashore. We talked about the fish, the birds and the boats. "Where is the boat?" I asked. "There it is!" the young man exclaimed. As soon as his sister looked, I made the image.

Props

The props are the nice, natural clothing. The grass, the water, and even the wind, are also props. The wind gives this image a spontaneous look. Some portraits have a very posed and controlled look to them, and with some subjects, that is just fine. However, with many of my children's portraits I enjoy a more natural and real look. I want the viewer to feel as though they are watching life happening, not being manipulated.

Photography

I like the composition with the children placed in the lower left-hand corner of the image. I placed them so that the shoreline forms a slight S-curve. This brings your eye into the photograph at the lower left (on the subjects). Then your eye tends to follow the curve of the shore along to the right. Here you see an out of focus boat. Because of the lack of focus, your eye goes back to the subjects. I used a high camera angle to keep the horizon from intersecting the subjects. A small ladder is a great piece of equipment to have with you for such occasions. The beautiful light comes from the late hour of the day. I find the last hour of the day to provide the most beautiful light of the day. It was so windy that afternoon that we had to go to this side of the island where there were some houses and trees to block some of the wind. There was a bank of clouds at the horizon. The light was getting perfect, then the sun dropped behind the clouds and we lost 2 stops of light immediately. We had to work very fast. The film used was Kodak PPF. The exposure was 1/60 at f-5.6.

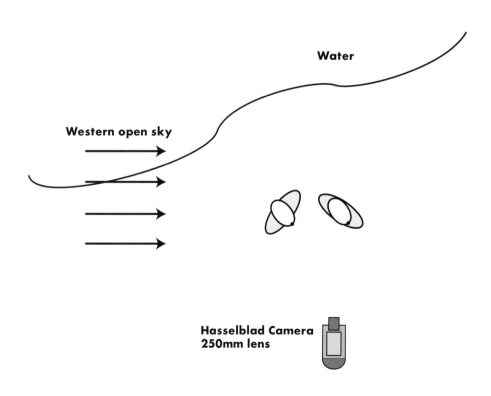

Water

Western open sky

Hasselblad Camera
250mm lens

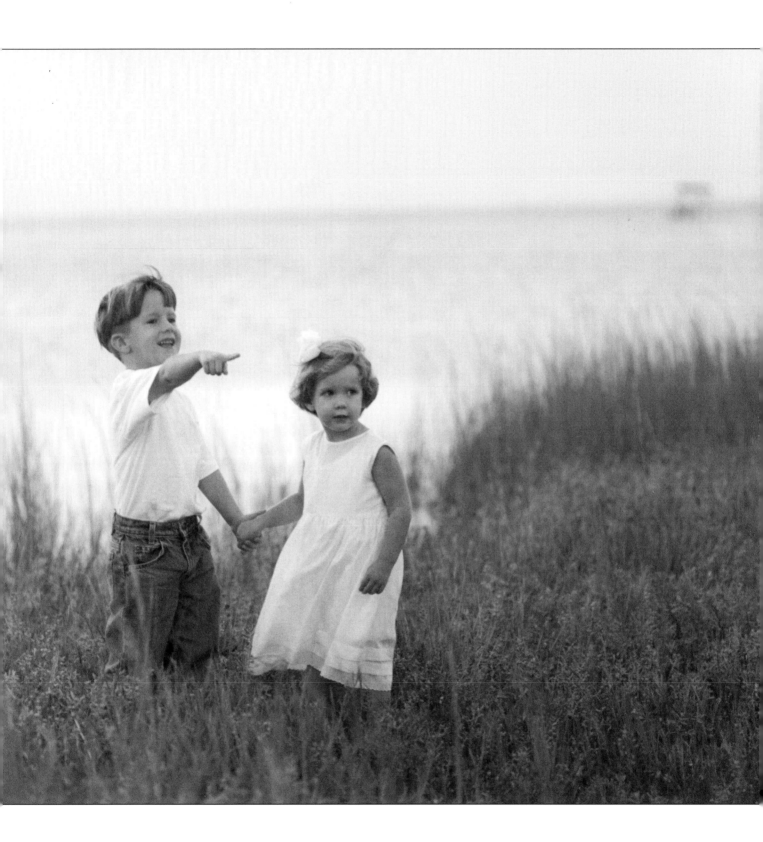

Praying

Pose

This is the first in a series of two images. The pose is a kneeling pose at the boy's own bed. I typically do not like shooting straight into the shoulders. So I turned his shoulders slightly toward the camera to give a larger "base" for the head to rest on. I think this little turn is one of those small things that makes a big difference.

Prop

This is his bed in his room and his picture on the wall. I like the "praying boy" picture on the wall. I let it go slightly out of focus and kept the light from directly hitting the picture. This keeps the attention off it, but is still a secondary subject.

Photography

Notice the placement of the softbox and reflector. The reflector serves two purposes. It adds light to the dark side of the face (the side away from the light), and it keeps the light from falling on the lens. I have placed an "x" on the diagram. This is a spot that if you moved the camera to this spot and moved nothing else, you would have a perfectly lit 2/3 view of the face. The point here is that in profile lighting, the lights are in the same position in regards to the face as a 2/3 view. Experience has shown me that if I take the meter reading as if I am making the exposure for the "x" and open up one stop I have the proper exposure for the profile shot. The film used was Kodak VPS. The exposure was 1/60 second at *f*-8.

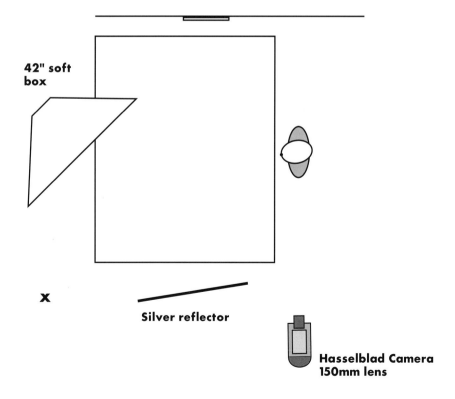

42" soft box

x

Silver reflector

Hasselblad Camera 150mm lens

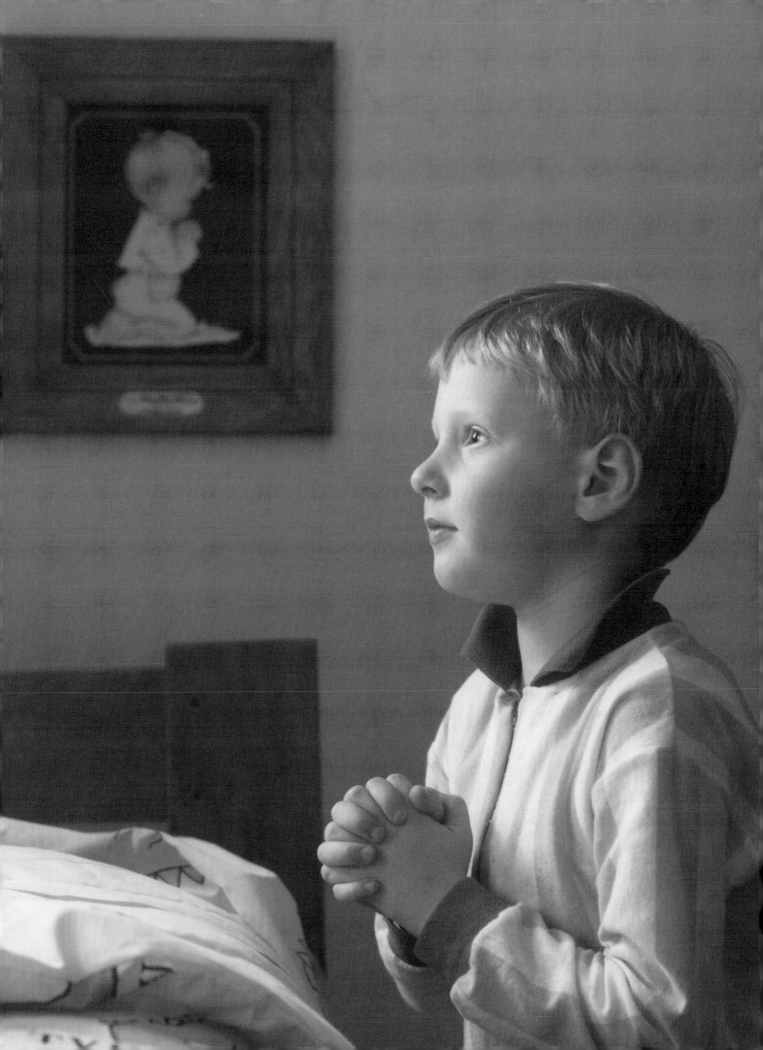

Really Praying

Pose

This of course is the same set up with a different child. The pose is the same, but he turned his face a little more toward the camera, which worked out great. It added a lot to the shot. Sometimes you just get lucky!

Photography

Let me talk a little more about the placement of the softbox and reflector. Start by placing the camera where you want it to get the profile photograph. Then, move yourself almost 90° to the left (to the x) this is where you would position the camera for a 2/3 view. Now place the lights as if you were going to photograph for this 2/3 view position. The back edge of the softbox is placed a little in front of the face of the subject. It is also turned so the main part of the light goes past the face and is aimed at the

place the reflector will be. Bring in the silver reflector approximately the same distance and position from the subject as the light. Then, turn the reflector back and forth until you have maximum light reflectance on the face. Take your meter reading by placing the flat disk near the face, pointed right at the camera. Now, open the lens up one stop and make the exposure for the profile position. You can use this formula for lighting many subjects. It gives you a controlled lighting situation with good direction and a good contrast range. The film used was Kodak VPS. The exposure was 1/60 second at f-8.

Psychology

This is the little brother. I told him to say a little prayer, then I told him pray real hard. This is the resulting photograph. You never know what you will get with children. This is why I love to work with kids – they are so uninhibited!

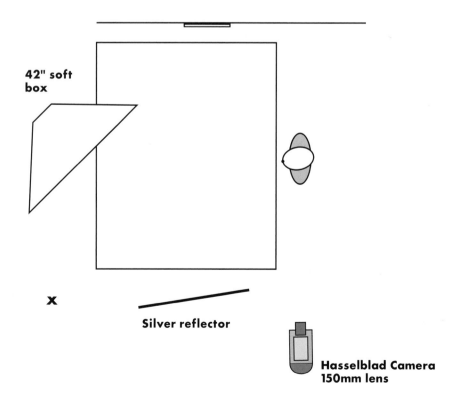

42" soft box

Silver reflector

x

**Hasselblad Camera
150mm lens**

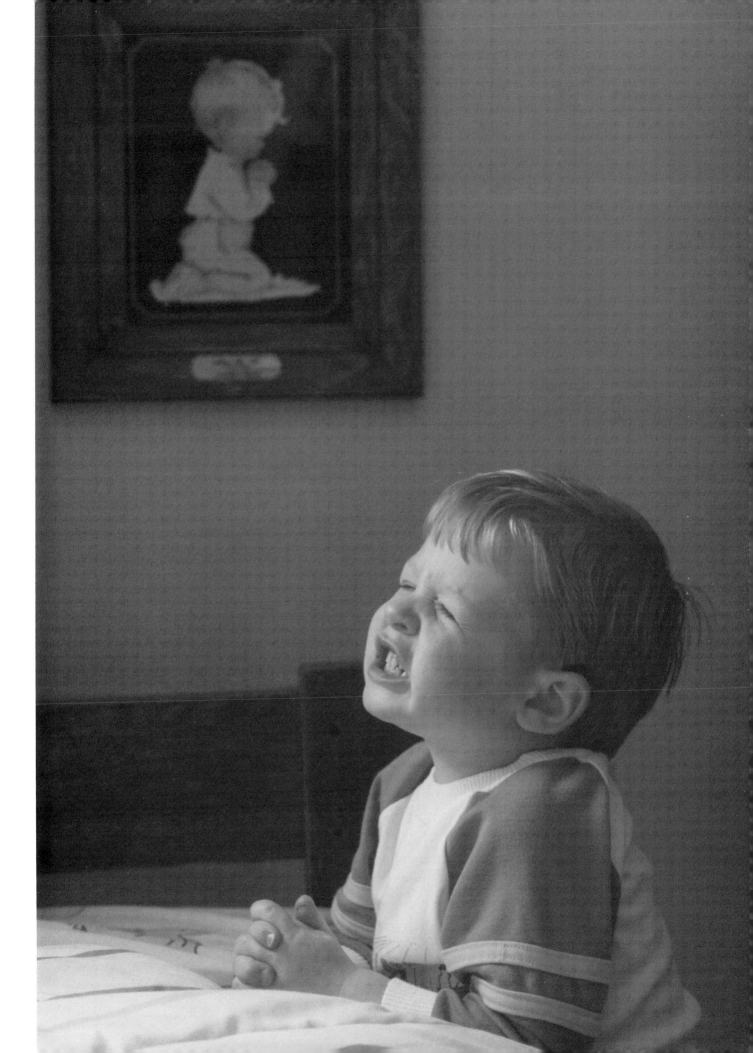

Brothers in the Sand

Pose

The boys were posed simply, just sitting on the beach. I did have them turn toward the open sky. I placed them far enough apart so that each boy has his own space. Usually I will have the head of the older child placed higher in the frame than the younger.

Props

I had the boys wear matching outfits: tee shirts and jeans. I love the simplicity of the rolled up jeans and bare feet.

Photography

Notice the direction of light coming from the right. This is accomplished by turning the boys toward the open sky. Behind and to the left are large trees. This gives roundness to the faces. I also used a home-made soft focus filter. It consists of a black scarf stretched over a plastic frame. The frame (called a filter frame) is made by Lindahl, they also make a great lens shade that holds filters and vignetters. Their number is listed in the suppliers' list at the back of this book. They will send you a catalog and let you know the nearest dealer. A lens shade is an important accessory to use on all your photographs. It prevents lens flare and even protects your lens. The film used was Kodak PPF. The exposure was 1/60 second at f-5.6

Psychology

The sillier you are with children the more fun they will have. The more fun they have the better the expressions will be. Never just say, "Smile!" and expect a good expression. Talk to them, ask them questions: "Do you have a pet?" "What is your favorite color, or cartoon, or music group?" Another question that always gets a laugh or fun expression is, "Are you married?"

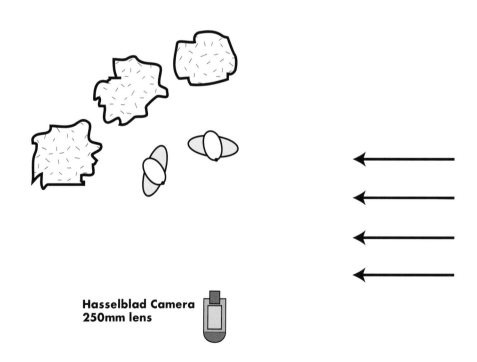

**Hasselblad Camera
250mm lens**

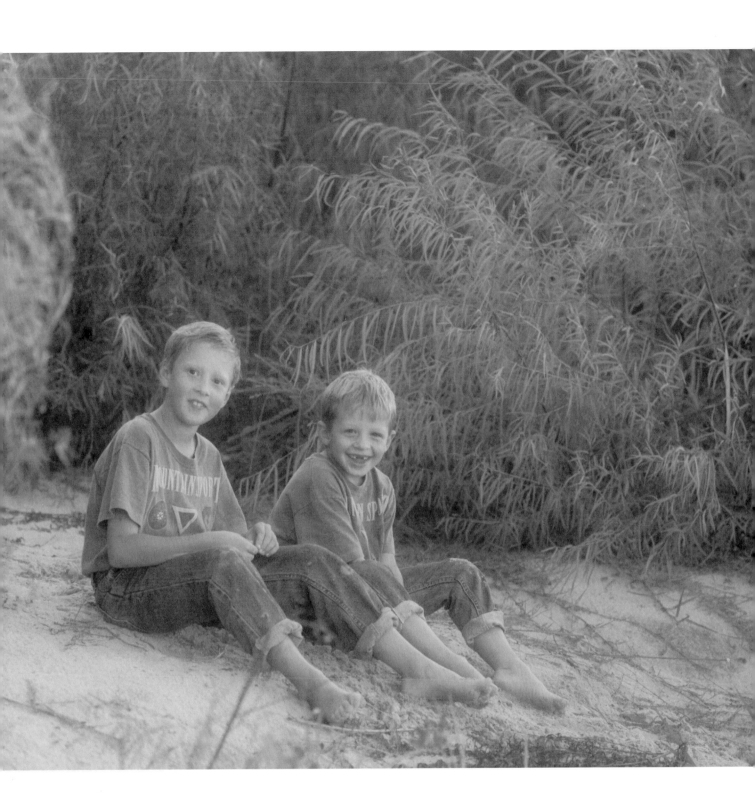

Pastel Bluebonnets

Pose

Posing brothers and sisters together can be difficult. Keep the poses simple. Make sure each person is in a good pose separately, then bring the two people together. The young lady has her weight on her back foot, her left. Her front foot is extended slightly. Both are in profile. When this image is mounted on canvas and lacquered in matte finish, it looks like a painting. It is one of my favorite images.

Props

The Bluebonnet is the Texas state flower. Each year I get dozens of calls wanting families and children to be photographed in these large fields of wildflowers. The background is the prop. I let the children pick or hold flowers. The subtle tones in the children's clothing keeps your attention away from the outfits and on the subjects.

Background

The problem with these flowers is they only grow in the bright sun. To get these rich colors I chose the late afternoon light. The sun is setting just behind the children. There is a bank of trees directly behind them giving the light some direction. Just a few minutes earlier, the sun was shining harshly on the children and the background. By waiting just a few minutes for the sun to go down, the saturation of the colors was increased.

Photography

I used the 250mm lens to throw the background out of focus, thus isolating the subject more than would be possible with a 150mm lens. This lens also has a narrower angle of view, showing less of the background. This gives the illusion of a larger field of flowers. I almost always use a tripod and cable release. I also use the mirror up release on the Hasselblad. This will help increase the sharpness of your images, especially when using telephoto lenses. Exposure was 1/30 second at f-5.6. The film used was Kodak PPF rated at 320.

Psychology

One of the skills you will need to learn if you want to be successful in photographing children is reading the moods and dispositions of the children you are working with. I usually talk to children like they are adults. They are much more intelligent and perceptive than most people give them credit for. Level with them. Tell them what you need them to do. Tell them how long it will take. Then have fun with them. Don't make it boring. Let them become involved in the process. Ask their opinion on how they would like to be photographed. You will be surprised at what they come up with.

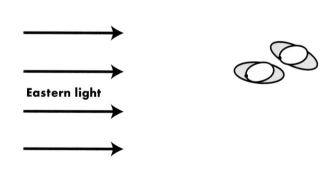

Eastern light

**Hasselblad Camera
250mm lens**

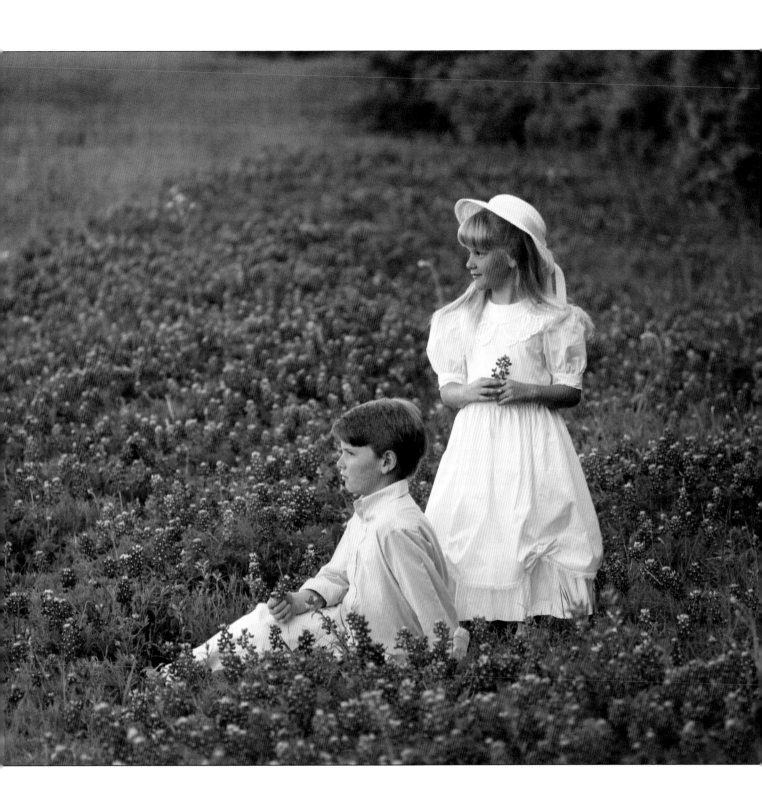

The Doorway

Photography

I had the mother hold a reflector to block the sun from hitting the girls. I metered the light outside the doorway and set the camera for that exposure. I used the spot meter function on the Sekonic L-508 meter. The lighter image (this page) is the way the lab printed it originally. I visualized it more like the darker image (opposite page). So I sent the negative back and ask them to 'print it down'. This is still a machine print, it is just printed darker. Look at the difference in the feeling of the two images. Many times the lab can change the density on the print. Just ask if they can print it differently. The film used was Kodak PPF. The exposure was 1/60 second at *f*-5.6

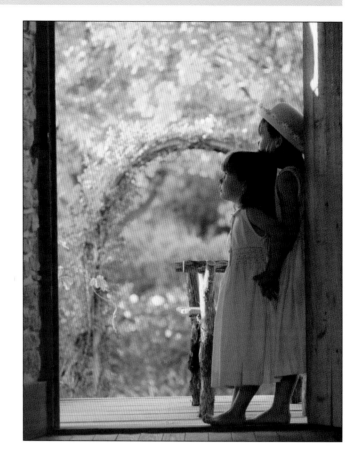

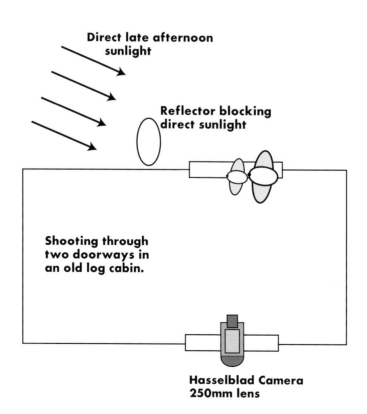

Direct late afternoon sunlight

Reflector blocking direct sunlight

Shooting through two doorways in an old log cabin.

Hasselblad Camera 250mm lens

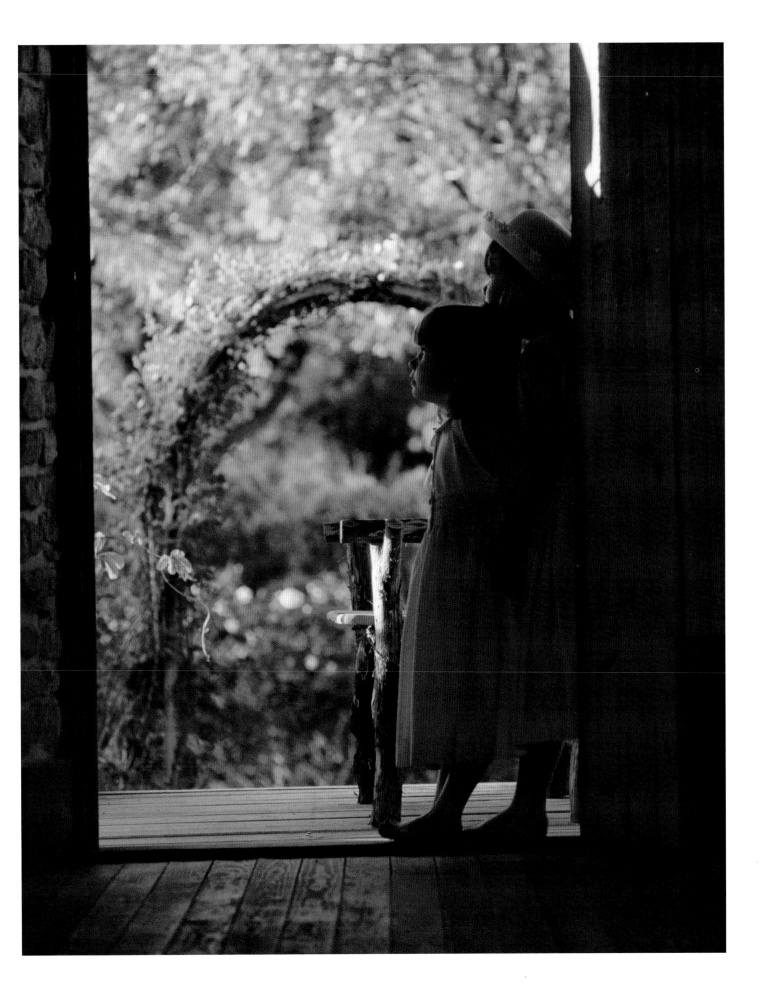

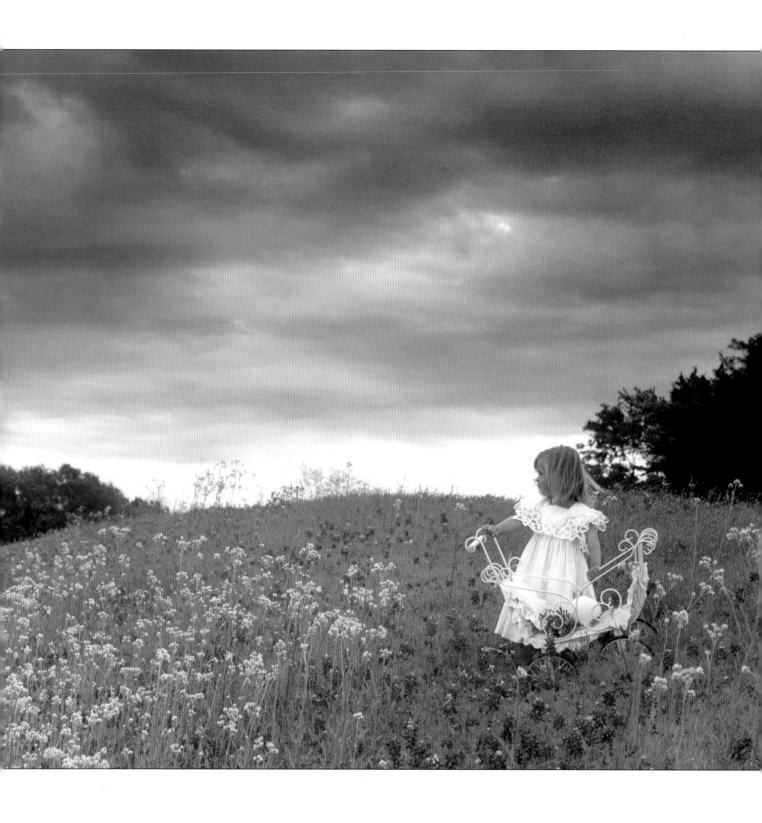

Beautiful Sky and Buggy

Pose

Feet separated gives stability to the pose, and a sense of strength. I felt that strength was needed because of the strong composition used in the image. I placed the child in the lower right hand third of the image. This made the child seem small in a great big world. I placed a lot of space in front of the child. This gives the subject room to move in the picture. This gives a more pleasing feeling to the image.

Props

Mom brought the buggy and the bunny. Yes there is a small pet rabbit in the buggy. This certainly kept the young lady preoccupied, not thinking of me and being photographed. She was concentrating on her little friend. The simple clothing adds to the peaceful feeling of the image.

Photography

Early morning light was soft, and the clouds added to this softness. I wanted to enhance the feeling of the stormy looking clouds. I knew I could have the lab burn in (print darker) on a custom print, however I wanted to be able to make a machine or automated print. This would save the client money. I used a half grey Coken filter held in front of the lens. This darkened the sky and added a little drama to the image. The film used was Kodak PPF. The exposure was 1/60 second at f-8.

Psychology

This young lady was quite cooperative. I had worked with her before and had established a rapport. We talked about her rabbit and what he was doing in her buggy. To get her to look off, I asked her if she could see another bunny off in the grass. She looked and we got the image we wanted.

Buggy

**Hasselblad Camera
120mm lens**

The Lesson

Pose

We were doing a family photograph, both with and without the horses. We had finished the 'without the horses' portraits and dad and the boys went to get the horses. I was visiting with mom when I looked up and saw them walking back with the animals. "Stop!" I shouted. With just a little direction we were able to create this outstanding image. I especially love the interaction between dad and the youngest boy.

Props

The horses are an important prop, but I feel the clothing is even more important. You probably wouldn't even notice the clothing unless it was pointed out – and that's great! The picture is about the people, not their clothes. I know it sounds a little old fashioned, but when everyone is dressed alike, the image is nicer.

Photography

The 250mm lens made the background go out of focus, making it less distracting. The bright sky at the upper right of the image is still a little bit distracting, but this could easily be cropped. I metered this image the way I almost always meter, with the flat disk pointed directly at the camera. I have invested in a new meter recently – the Sekonic L-508 Zoom Master. It is the finest meter I have ever owned. It is both a reflected and incident meter. The reflected meter is a 1° to 4° zoom spot meter. The meter also has a dome that is retractable to be used as a flat disk. It features a large lighted display with large numbers, dual ISO settings, weather resistance and best of all it uses one AA battery! If you get a chance to use one of these you will fall in love with it. For this image, I used the flat disk to read the light falling on the front of the subjects. The flat disk is great for this because if I would have used the dome, some of the direct sunlight would have hit the dome causing an under exposed negative. The spot meter was used to read the sunlight falling on the subjects. Because it was only 2 stops brighter the light on the faces of the people, I knew it would not 'blow out' the highlights. If the reading would have been 4-5 stops more, the highlights would have looked white where it hit the subjects The film used was Kodak PPF. The exposure was 1/60 second at f-5.6.

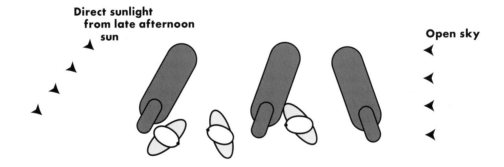

Direct sunlight from late afternoon sun

Open sky

Hasselblad Camera 250mm lens

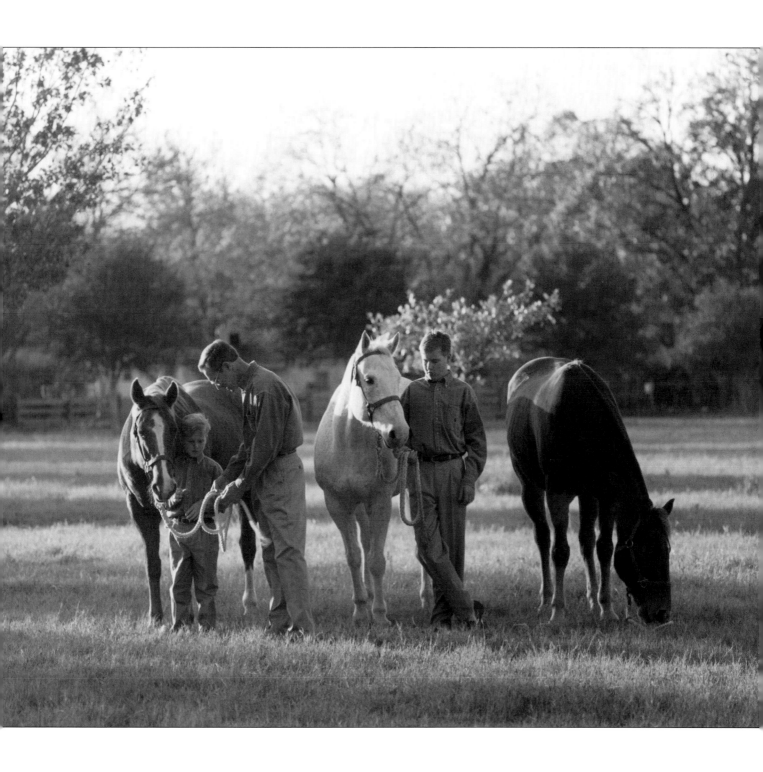

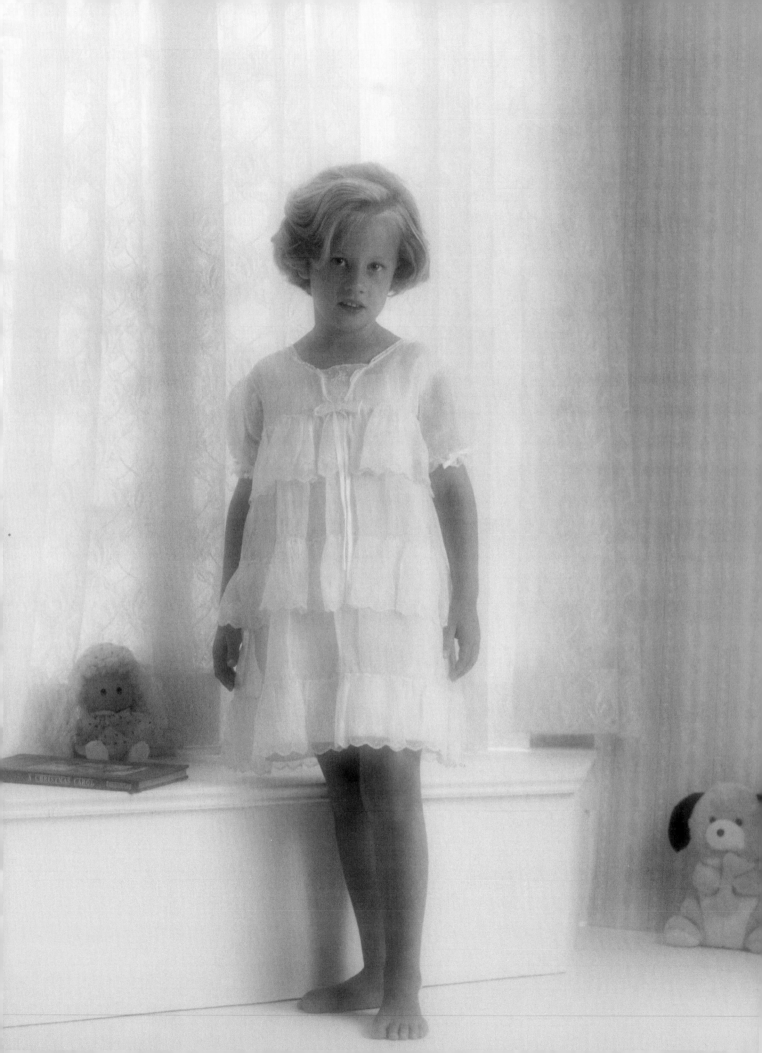

Simple in White

Pose

This is a very simple, straightforward portrait but there are several things we can learn from it. The posing is "back to the basics." The child's weight was placed on her back foot, her shoulders were turned away from the light and her face was turned back toward the light. It is classic feminine posing with the back shoulder slightly dropped, forward foot pointed toward the camera. It is simple but elegant.

Prop

The bear, the doll and the book were used to create the look of a little girl's room. Notice that I kept the light off of these props to keep them from becoming too prominent in the image. The little white dress and bare feet complete the overall simple look.

Background

This white room appears in other images in this book. The only difference is the addition of the wallboard paneling leaned up against the fake window. I also added the window seat in front of the window. This also shows the painted floor I added instead of the white paper. While this was actually taken in the studio, it's a look that could also be created on loction with the sunlight coming through a window.

Photography

Please notice the placement of the umbrella and the reflector. I usually place the light source in just this position with the back side of the apparatus (whether it is an umbrella, softbox box or light scrim) just slightly in front of the subject and feathered past the subject. This way the main intensity of the light goes past the person and hits the reflector. I place the reflector in the same position except on the other side of the little girl. Visually turn the reflector until it gives you the maximum light return. The film used was Kodak VPS.

Clothing

A book of "proper" clothing samples is very helpful. This is very important to the final quality of the image and something with which clients need guidance. Here are some guidelines. PJs and nightgowns are great. Shoes should always be clean and neat and must match the clothing. It is always best to bring several outfits ranging from casual to formal. Bring several items you wish to have in the portrait and we can tell you which will photograph best. Page 121 contains a detailed handout of guidelines for customers.

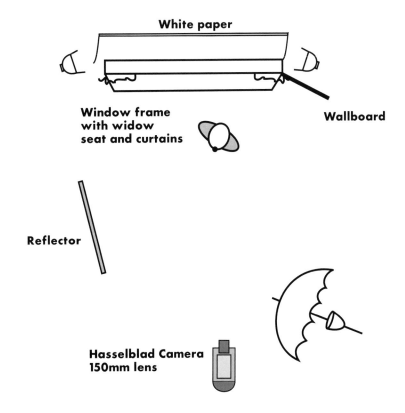

White paper

Window frame
with widow
seat and curtains

Wallboard

Reflector

Hasselblad Camera
150mm lens

Silhouette Boys

Pose

As you can see throughout this book, I believe if you leave children alone, they will probably pose themselves. I feel this pose shows how the two brothers feel about each other. It also shows the adventure and wonderment of little boys.

Props

The prop is the sunset. It allowed for the silhouette. The silhouette makes the image dramatic. Because you can not see the faces you concentrate on what is happening in the image and on the composition.

Photography

A scene like this has a large range of tones, and extremes in contrast from the contrast from very light to very dark shades. The best way to meter this is with a reflective or spot meter. Most 35mm cameras are equipped with a reflective meter. If your camera has an averaging metering system, it will take the entire range of tones and average then to give you a reading. A spot or center weighted meter can single out a small section of the scene from which to take the reading. Make your reading from whatever part of the scene you wish to emphasize. In this case it was the middle tones of the sky. The film used was Kodak VPH. The exposure was 1/60 second at *f*-8.

Psychology

When photographing their own children, many people don't have as much patience as they do photographing someone else's children. I try not to be that way. On this particular occasion, I asked my sons if they wanted to go to the lake. Going to the lake sounds like more fun than taking pictures. I wanted to make this day an experience, a good experience. I told them, "While we are there let's take some pictures. David you can take some pictures of Derrick and Derrick you can take some pictures of David." While helping them photograph each other, I made images of them for me. We had a picnic dinner, played on some playground equipment, took a nature walk and did portraiture in between. The sun began to set and the sky turned a beautiful golden orange. The last few images were made while the boys were being the inquisitive, adventurous boys that they are. A beautiful, memorable portrait topped off a great experience.

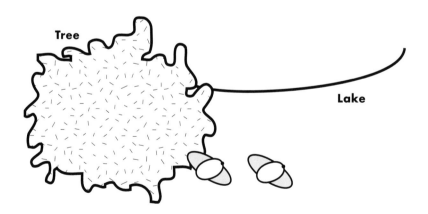

Tree

Lake

Hasselblad Camera
150mm lens

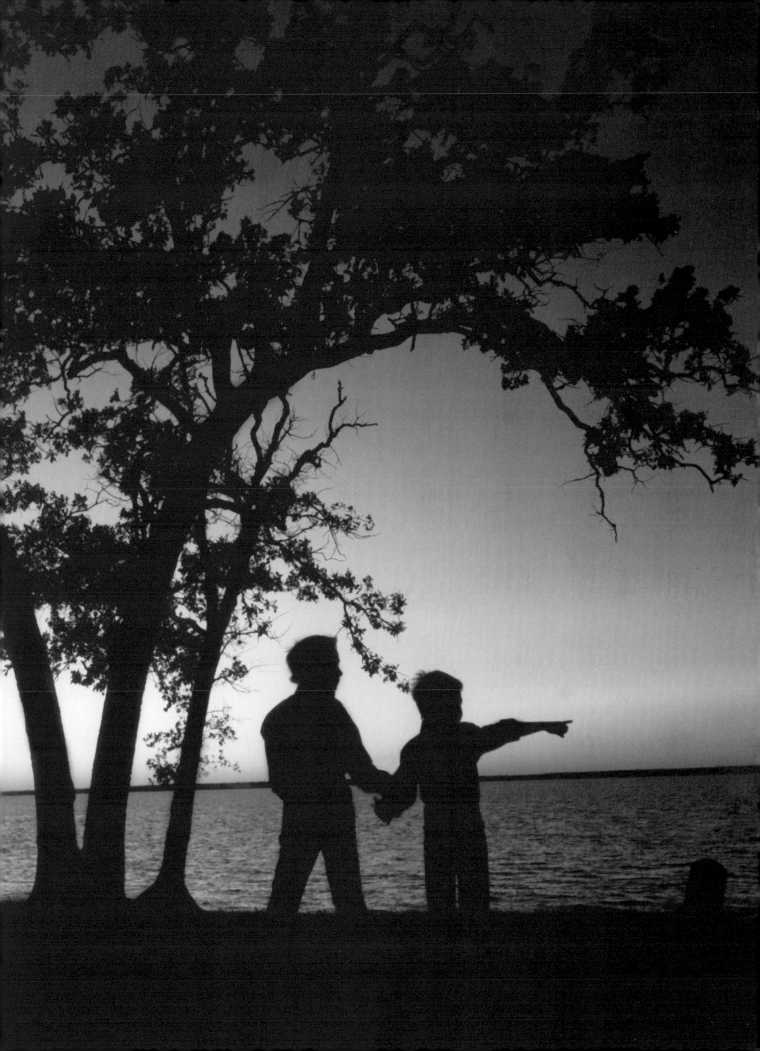

Three Brothers, Dark Shirts

Pose

This is a two photograph series. This first photograph is a simple "half length" portrait of three boys. The older boy is sitting on a small bench, the youngest standing, and the middle boy is leaning an arm on his knee. What makes this image important to study is the clothing.

Prop

The clothing is the prop. When we first talked to the mother, she indicated she had these dark shirts for her sons. Another photographer had told her to dress all the boys in dark clothing. We told her to bring these shirts but asked if she could also bring matching outfits – something like blue denim. We took a series of photographs in the dark outfits, then had them change into the matching outfits. I hope you will agree that the image on page 87 is much nicer, mainly because of the clothes!

Background

The boys were posed outside by a bank of large evergreen bushes. The small bench is made from a large slab of rock resting on some smaller rocks.

Photography

The 250mm lens was used to isolate the subjects and also to break up the hot spots in the background. The exposure was 1/60 second at f-5.6. The film used was Kodak PPF. I love this film, especially the 400 speed. I know I can count on it. The extra stop and a half is great for the f-5.6 lens and late afternoon lighting level.

Psychology

When I work with older children, I treat them with a lot of respect. I let them know what to expect from me. I let them know how long this will take, and that I don't expect them to smile all the time. I tell them that I want to do some images for their mom, some images for me and some images just for them!

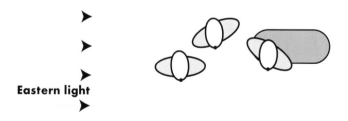

Eastern light

**Hasselblad Camera
250mm lens**

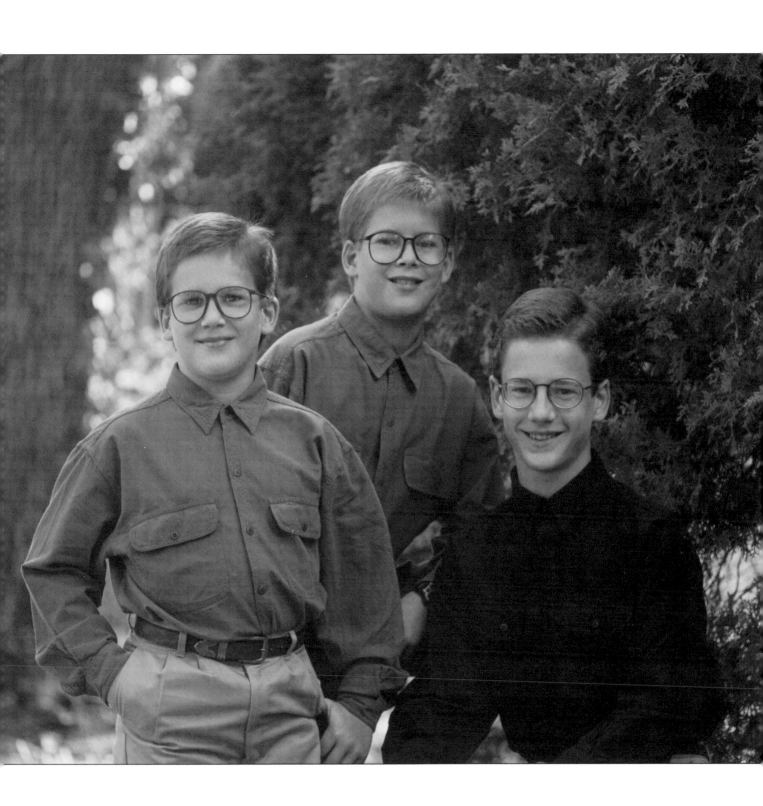

Three Brothers, Better Choices

Pose

The goal in posing in this image is to place all the heads at different levels. This is accomplished by sitting, kneeling and standing on and around the fence. I like to work with a triangle composition. There is a natural triangle composition with the heads of the three boys. There is also a modified triangle composition with the whole image and the posing of the young men.

Prop

I prefer that pants be darker than shirts. This keeps your eyes from bouncing between the faces and the lighter colored pants. Also shoes can cause a small problem. One of the boys had dirty shoes and we had to do some retouching on his shoes on the enlargement. If I had my choice, I like dark shoes instead of white sneakers, because the white tends to draw your eye away from the faces. But I also realize that white sneakers are real.

Background

This is just a corner of a split rail fence at the studio. This is a very versatile prop. It works great for children, families, seniors and groups. It can have a western flair or just a country setting.

Photography

The 250mm lens does a good job of throwing the background out of focus thereby separating the boys from the bushes. This was photographed about one hour before sunset. Exposure was 1/60 at *f*-5.6, film Kodak PPF. If you look closely at the eyeglasses on the boys, you can see what is commonly called "glass glare." I did not have it removed for the book so that you could see what it would look like in this situation. There are a couple of ways to remove or retouch this. One is conventional "dry dye" spotting of the light colors in the glasses, to match the dark colors around the area. However, with the new technology of electronic imaging, glass glare can be taken care of "digitally." Burrell Color, the lab that printed the images for this book, can scan your negative into their computer system. They can clone the areas around the glare and replace the "glare area" with the proper color and completely remove the problem. They then output the electronic file to a new negative. This new negative can be printed by conventional means. This is especially great if you need to print several prints from the same negative.

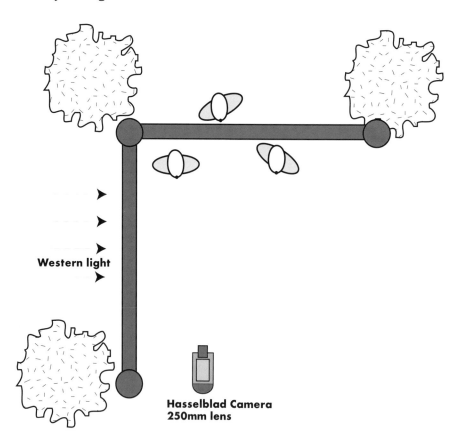

Western light

**Hasselblad Camera
250mm lens**

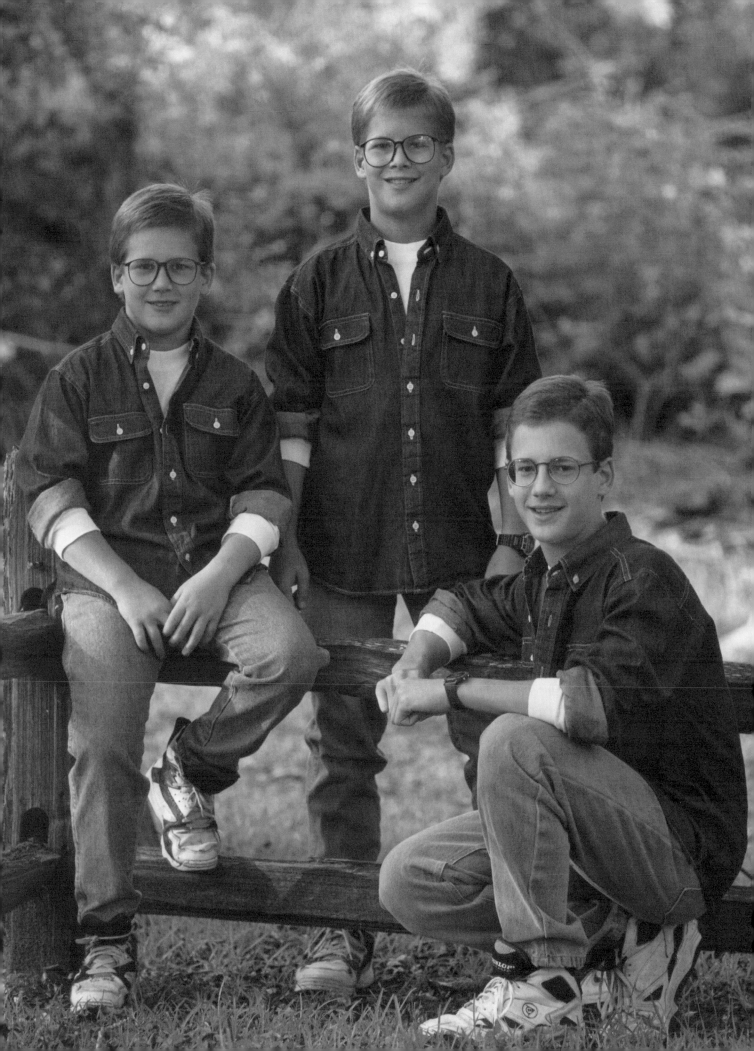

Little Horse Girl

Pose

Believe it or not, this little girl rides this horse all the time. We did a series of images, from her feeding the animal to simply holding the reins. This was my favorite. It seems so natural. I certainly did not have to encourage the horse to eat!

Props

I asked the mom to dress the youngster in simple clothing. Many times western clothing can be quite loud. I think the simplicity of the outfit adds to the overall feel of the photograph. The horse is hers, the image was taken on their property. I enjoy the scale of the image – the large animal with the very small child. I also like the space around the subjects.

Photography

The time of day is what makes the lighting so beautiful. The sun had already gone down. The light value was low. Three things made the image possible with the 250mm lens on the Hasselblad: a tripod and the 400 speed of Kodak PPF film, and the mirror lock up feature on the Hasselblad. The mirror lock up feature adds to the sharpness of the photograph. I also recommend the usage of a cable release to reduce camera movement. The exposure was wide open, *f*-5.6, at 1/30 of a second – quite slow for this long lens.

Psychology

We did family photographs a few minutes earlier. We used riding the horse as a reward. I did some images on the horse. We had promised her so we had to come through. The we coaxed her to get down and feed the horse. It worked!

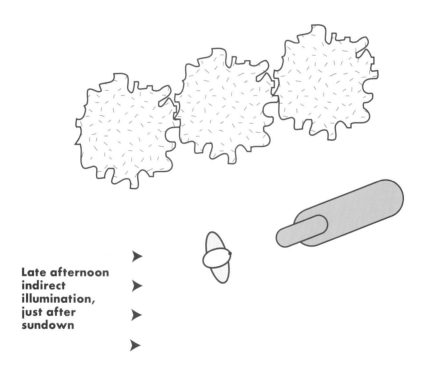

**Late afternoon
indirect
illumination,
just after
sundown**

**Hasselblad Camera
250mm lens**

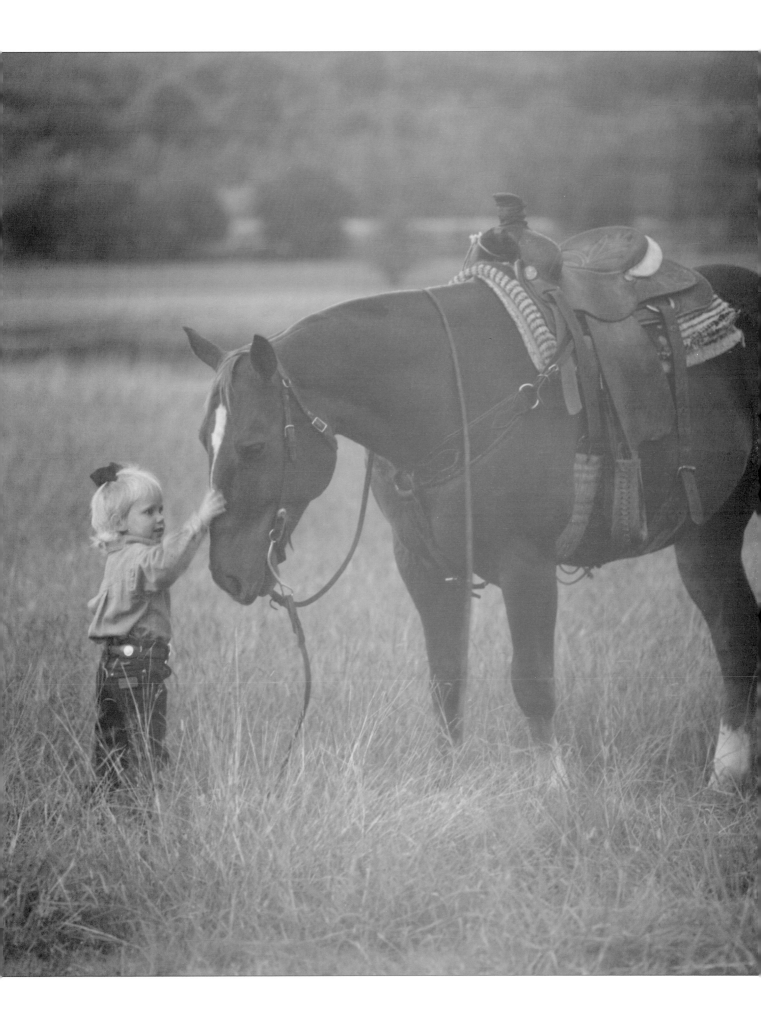

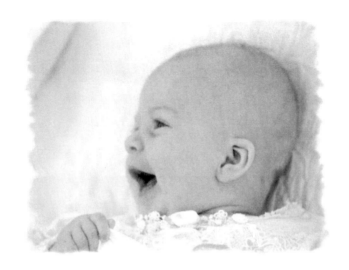

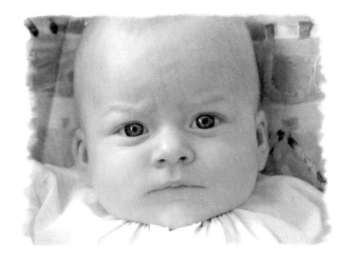

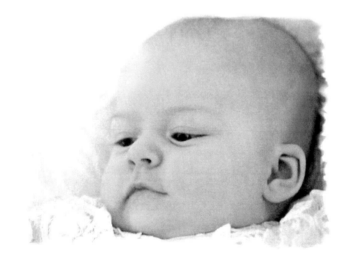

Just the Faces

Pose

Sometimes the simplest pose is the best. The baby is simply laying on her mother's bed, propped up by pillows.

Photography

The lighting is coming in from the left through a window. The light was indirect sunlight. I was testing Kodak's TMZ 3200 speed black and white film. The high ISO film speed let me hand hold the camera. This lets me work fast and capture images quickly. The exposure was 1/250 second at f-8. The Nikon 8008S is a great camera for this type of photography because it focuses quickly and the computer in the camera is able to average the light and give great exposure without me having to concentrate on the camera. Instead I can concentrate on the subject. I moved up close to capture "just the faces" and the expressions. When I presented the image to the client, the three prints were printed side by side in a horizontal arrangement. It was printed on watercolor paper by Pacific Color on an Iris printer. The images were about 5"x7" in size on a 10"x28" piece of paper. The overall presentation was wonderful. I especially love the middle image. Look at those eyes!

Psychology

I love working with babies. I seem to be able to get good expressions. Maybe I have a funny face to babies. I like to get in real close and make soft kissing sounds and then move back quickly. I talk softly and laugh a lot with babies. It seems to calm them. Then you can whistle or make a funny sound and you might get the middle expression, but be quick. It won't last long!

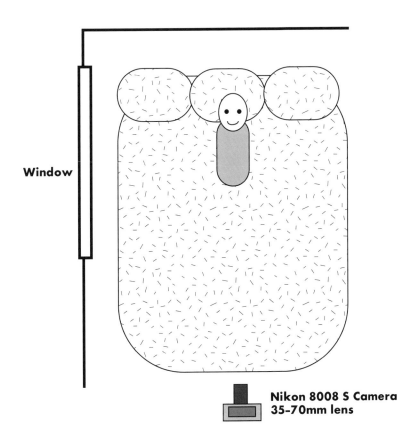

Window

**Nikon 8008 S Camera
35–70mm lens**

Brothers in Red

Pose

See how nice it is when the clothing is the same? I put the log down for these two brothers so each could place a foot on it. The youngest boy would fall down after about 15 seconds of trying to balance with one foot on the log. Without his foot on the log, he looked so boring just standing there. So the mother got his jacket, I had him throw it over his shoulder, and I think it makes the photograph.

Prop

As described above, the clothing is the prop. The only other prop is the log. I got that out of the wood pile.

Background

This is a line of trees on the north side of the property. As you can see by the hot spots above the boys' heads, this was not taken at the "right time of the day." It was late morning. The trees blocked out most of the sun. When I printed this for the client, I had to have custom printing to burn down that area, plus a little print enhancement. My favorite time to photograph outdoors is the hour before sunset up until about 15 minutes after sunset.

Photography

The main "photographic" thing I did with this image was to use a Larson black umbrella. Notice in the drawing, I held the umbrella over the boys, with a light stand, placing the back edge about in the middle of their heads. You can see in the photograph that I achieved a nice hair light effect by moving the light block forward and exposing part of their heads to the top light. The film used was Kodak VPS. The exposure was 1/60 second at f-5.6.

Psychology

Clothing is a "key" to a successful portrait. I advise parents when planning for their session that one of the outfits for the session should be in solid colors, without designs. Groups of children should have complimentary or matching clothing. In fact, matching clothes in my opinion, look best. To me, the fact that the outfits are exactly the same in this image, "makes" the photograph.

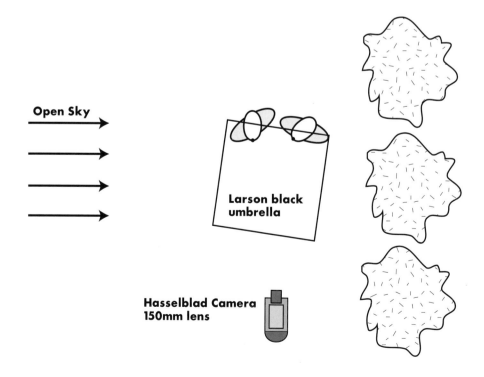

Open Sky

Larson black umbrella

Hasselblad Camera 150mm lens

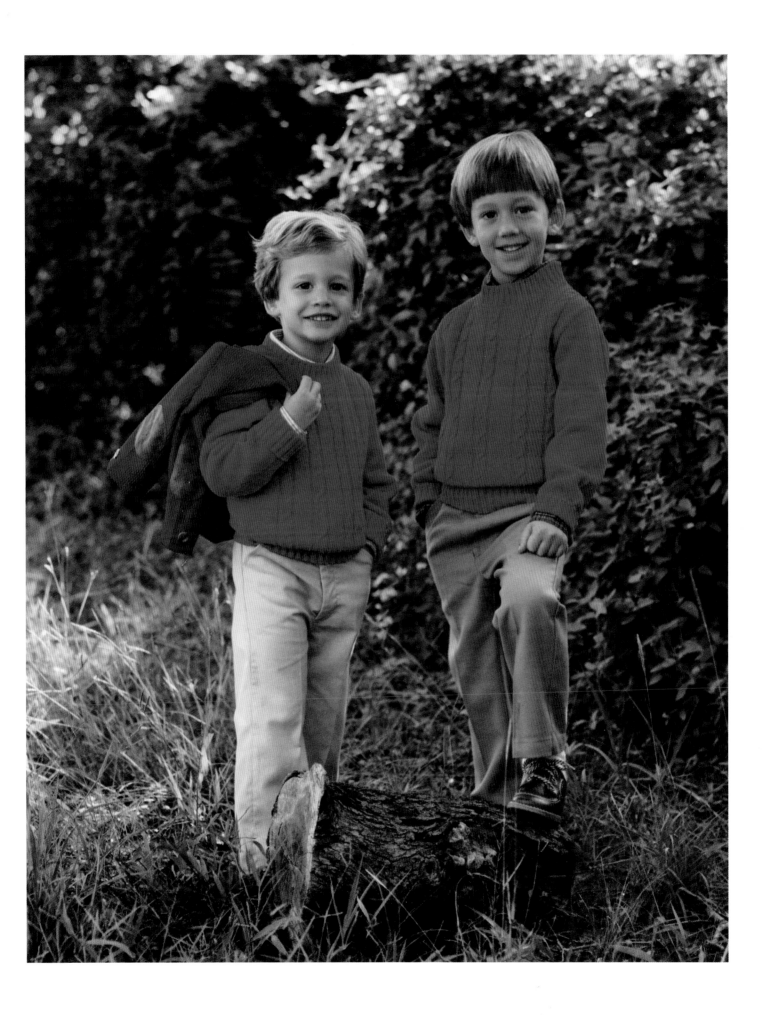

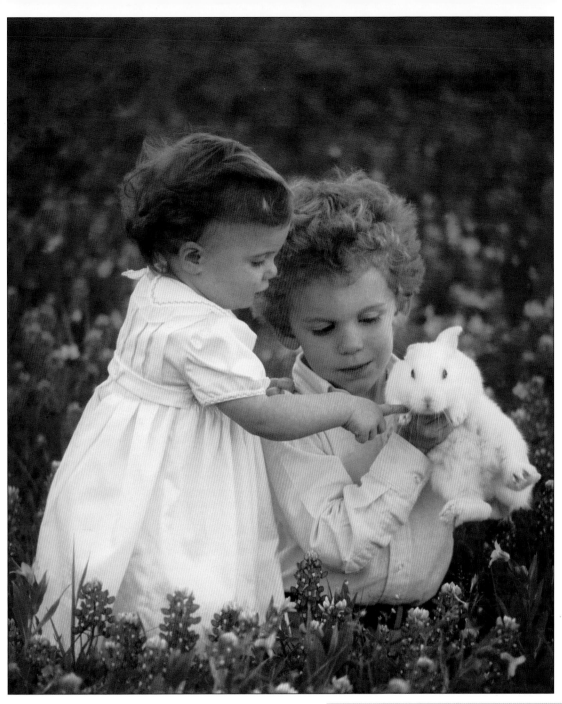

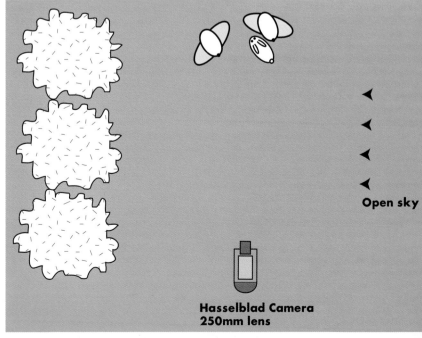

Open sky

Hasselblad Camera
250mm lens

Wildflowers (Two Different Lighting Situations)

Photography

There are two major differences between these two images: time of day and the lens selection. The image with mom and the two boys was taken a little earlier in the day than the other image. Notice the sunlight hitting the subjects. This has a warmer, very spontaneous feel. I like the lighting on the subjects but the bluebonnets don't have as rich a color as the image with the two children and the bunny. I also used a little fill flash on the image with the sunlight. It is used to 'fill in' the dark side of the face. Without it, the side of the faces facing the camera would have been darker.

The second image, with the bunny, was taken after the sun was down below the tree line. This 'open shade' lighting situation gives a more even lighting situation. It also increases the saturation of color to the background. Look at the subtle direction of light on the children's faces. Also look at the way the 250mm lens compresses the background. The first image gives us the feel of a large field of flowers. This second image has a more intimate feeling. The film used was Kodak VPS.

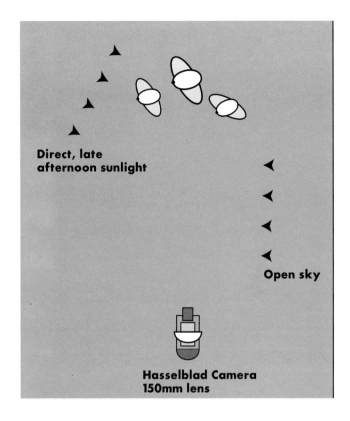

Direct, late afternoon sunlight

Open sky

Hasselblad Camera 150mm lens

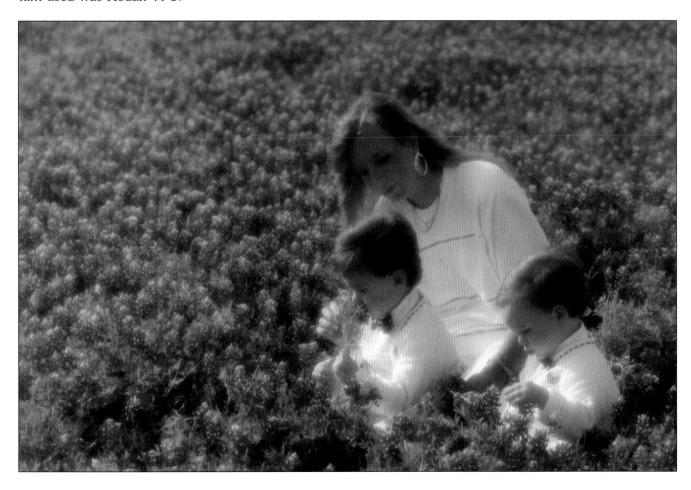

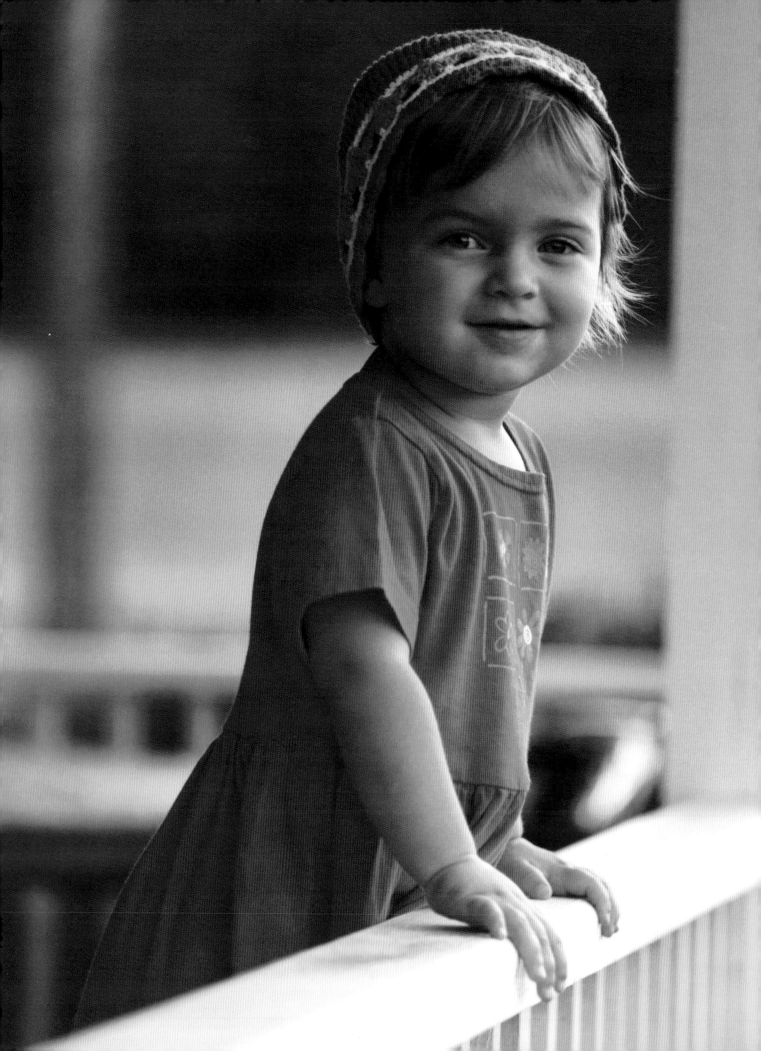

Pink on the Porch

Pose

The child is standing on a small bench to bring her to the right height for the rail. The camera was already set up and prefocused. As soon as the dad placed the child on the bench, I began to play peek-a-boo around the camera. She lit up with this beautiful and natural expression. I love the delicate way she is placing her right hand on the top rail. Sometimes you just get lucky with children.

Prop

Her mom brought this beautiful knitted hat. She asked if she could include it in a couple of photographs. I knew when I saw the hat it would photograph very well.

Background

The porch is on a one hundred year old house that is at a bed and breakfast in the country, where the family was staying.

Photography

The 250mm lens throws the background totally out of focus and compresses the railing. All of this helps isolate the subject. The time of day is late afternoon, about one hour before sunset. The exposure was 1/60 second at f-5.6 The film used was Kodak PPF.

Psychology

Many times with small children, a simple game of peek-a-boo, hiding behind my camera, is a fun game that results in great expressions. This photograph was taken while the family was on vacation at a local bed and breakfast. Vacations are a great time to do portraits. You are usually in a great place with lots of beautiful photographic opportunities and everyone is in a great mood. Make sure you bring appropriate clothes for portraiture. Solid colors or very simple patterns usually photograph best.

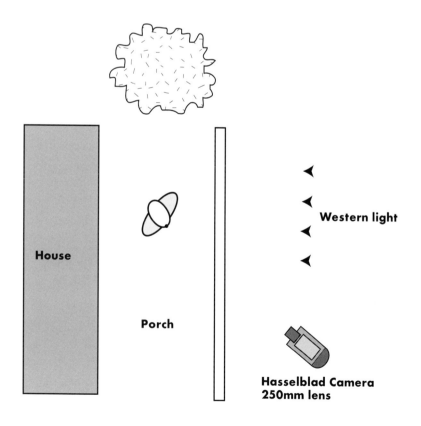

House

Porch

Western light

Hasselblad Camera
250mm lens

Hat and Flowers

Pose

I call this a 2/3 view of the face on this little girl. The rule is that the eyes should be contained within the outline of the face. The nose should also be kept within the outline of the face. As you can see, the little girl's eye is just within the outline of her right cheek What I enjoy most in this turn of her face is that it shows of her cute little round cheeks. The overall look of this image gives the impression of a candid view of her. That is what I visualized, and I think it worked.

Photography

Even though there is some light coming in from overhead, the hat blocks the top light from hitting the eyes. There is also a sufficient amount of light coming in from the open sky to the left. I did not use any supplimental lighting or controls to manipulate the lighting. I wanted the light to be very soft with almost no direction or contrast. I felt this matched the softness of her skin. The 200mm setting on the lens gives great separation from the background. It also allows you to stay far enough away from the subject to give you an opportunity to capture very candid images. The film used was Kodak. The exposure was 1/125 second at f-5.6. The diagram above shows the compositional rule of thirds. I have drawn horizontal and vertical lines at the 1/3 marks of the frame. Generally I like to place the subject in one of those four points where the lines intersect. The subject placement adds to bold composition of the image.

Prop

We were at her home creating some images for an amateur photography class I was going to teach. Her mom had given her the flowers, and I was following her around capturing some candid images. The hat and matching outfit are as much props as the flower.

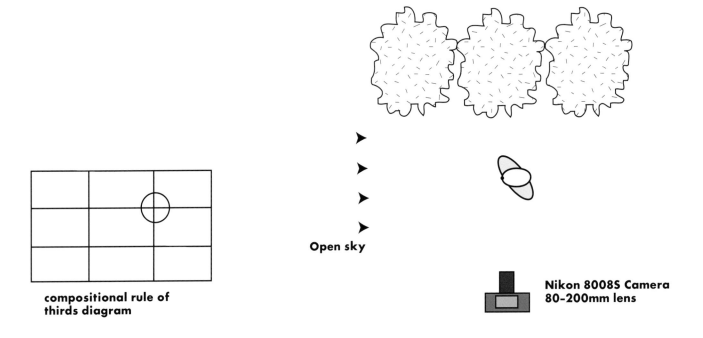

**compositional rule of
thirds diagram**

Open sky

**Nikon 8008S Camera
80-200mm lens**

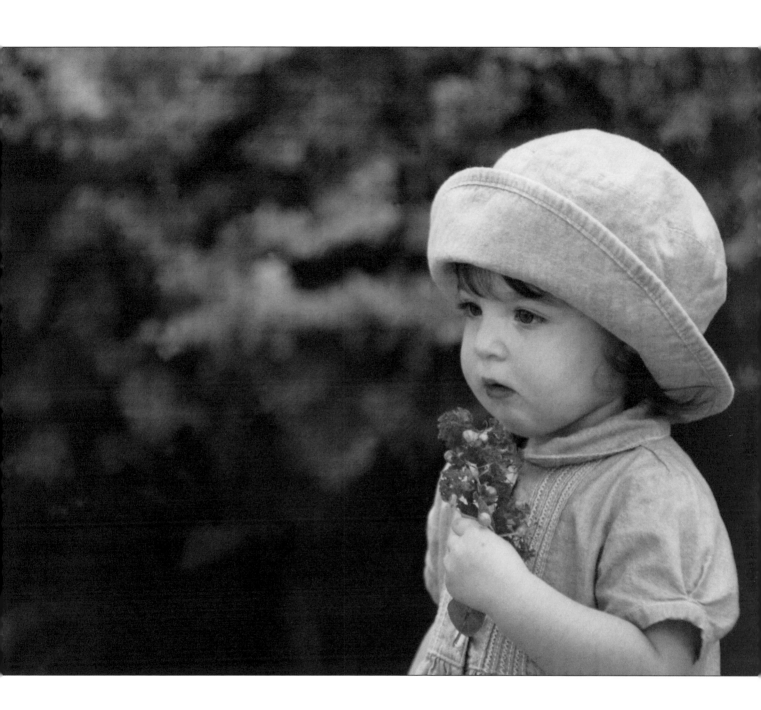

The Secret

Pose

If you will look closely in the upper right hand corner, you can see that the youngest girl is sitting on her mother's lap. This kept her still and kept her from falling. I just brought the two sisters together and waited for the right moment!

Props

Sometimes my favorite images are the simplest. This one captures the innocence and wonderment of childhood. It shows the relationship between sisters and the excitement that you can put on film.

Photography

This is another example of what you can do with a 35mm camera and window light. Window light is coming in from the right and some is coming in from behind me. I set the Nikon 8008S on program. Even thought there is a lot of white in the clothing, the darkness in the background ensures

that the metering system is not tricked into under-exposure. If you have a scene that is all white or all black you will have to adjust the over/under exposure compensation control. Remember, all reflective meters are set for gray – 18% gray to be exact. When a meter sees all white, it "thinks" this is gray with too much light on it. It then cuts down on the light hitting the film by changing the f-stop or shutter speed. In contrast, when a meter sees all black, it tries to make it grey by letting in more light. The result in this last case is overexposure. The film used was Kodak TMZ 3200 rated 3200. The exposure was 1/125 second at f-8.

Psychology

I will have to confess, I got lucky on this one. Their mother told the older sister to kiss the little sister and the resulting two images were the result. The images were printed on one sheet of watercolor paper by Pacific Color (see the suppliers' list at the back of this book).

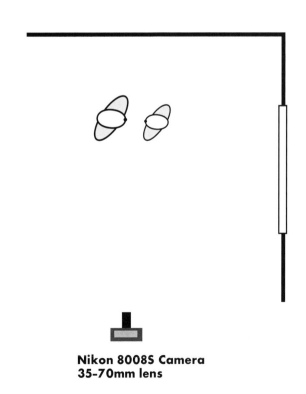

Nikon 8008S Camera
35-70mm lens

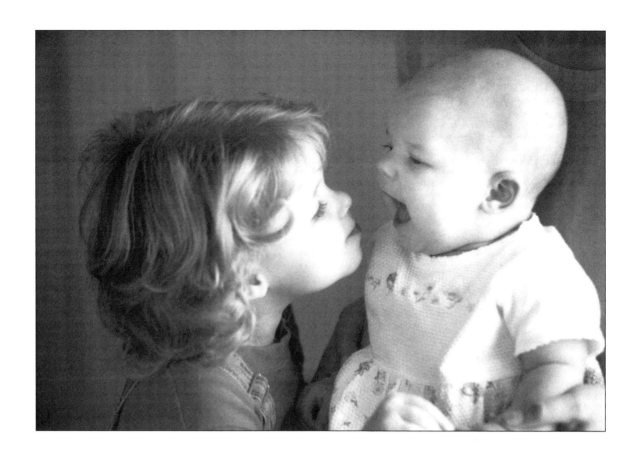

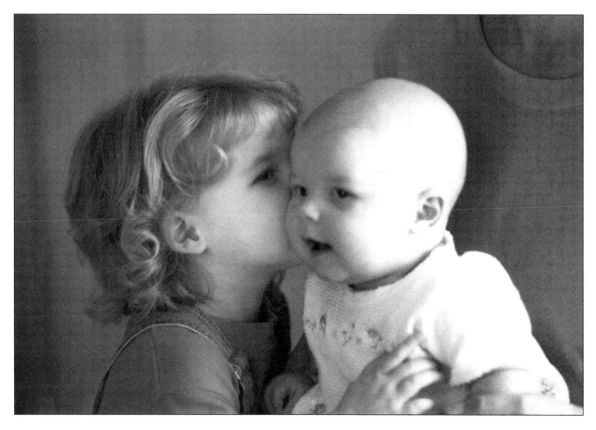

Three for One

Pose

With three young, active children, one of your best assets is working quickly. As I brought the children in close for the image I made several exposures very quickly. This was the only "good one." The pose is quite simple. The children in front are sitting on one step and the one in back is sitting on the next step up and looking over – simple, but effective. I also shot individual photographs for each of the children in very much the same way.

Props

The stairs and the window are the only props. I love the matching outfits. Because they match, they don't demand attention. Your eye, therefore, goes to the subjects – the children's faces.

Photography

It does not get any simpler than this: a camera, tripod, meter and natural light. The light coming in the window on the right serves as the "main light" (the light which provides direction). The light coming in from other windows in the entry way provides the fill light, the non-directional light that is the base exposure for the image. The film used was Kodak TriX. The exposure was 1/60 second at f-5.6.

Psychology

I shot the individual photographs first, building rapport with each child as I went along. I was learning the personality of each child and how to best get the reaction and results I wanted. Toward the end of the session, the children were losing interest. If you look in the hand of the child in the center, you will notice a small cookie. I am not above small rewards or bribes!

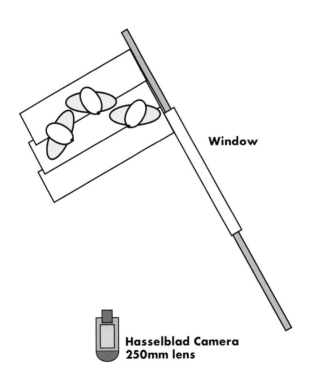

Window

**Hasselblad Camera
250mm lens**

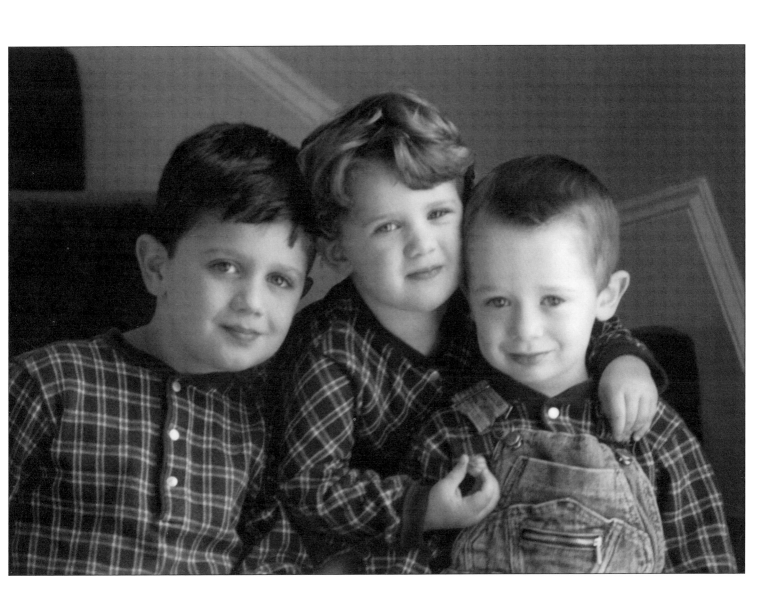

Wedding Photographs

The beauty of photographing a wedding is the relationships you build with the participants. Typically, I get down to the child's level and talk to him or her about the big job they will be doing that day.

One of the most exciting things to come out of our studio photographically is black and white, documentary style, wedding photographs. About a year ago, my wife Barbara informed me that she was going to bring a second car to weddings. "Receptions are boring!" she demanded. "Please don't," I begged. "If you're not there, it will make the receptions even more boring for me. Why don't you start taking some photographs?" Barbara has always enjoyed the detailed, close-up and emotionally charged images that I was doing at weddings, in addition to the more traditional images, especially the photographs of children.

Considering the following, I thought, "We might have something here!":
- She liked black and white photography.
- The Nikon 8008s auto focus, auto exposure 35 mm camera is very sophisticated.
- The great qualities of the high speed TMZ 3200 Kodak film - nice grain structure and a variable film speed (ISO 1200 - 6400) that is high enough that she could hand hold the camera and not need flash.
- She has an artistic eye.

With all of this, she could concentrate on the images and emotions and not the equipment. Barbara has also studied art and architecture. Those two disciplines have helped her create beautiful images. She also took her inspiration from some of the images of Dennis Reggie, Gary Fong, Laura Lund and of course me – then she developed her own style! Concentrating on design, line and form – along with emotion, feeling and excitement – she began to create beautiful and dynamic images.

Women see things differently!

As we teach this information around the country, we have seen a tremendous amount of interest, especially from women assistants and spouses that go to the wedding and are not usually involved in the creative process. We have had dozens of letters and calls from people who have tried this concept and have had great success with it. I hope you will try it.

The images on this and the next page are examples of Barbara's work at weddings. Push processing the TMZ 3200 film to achieve a nice grain structure is discussed in detail on page 107.

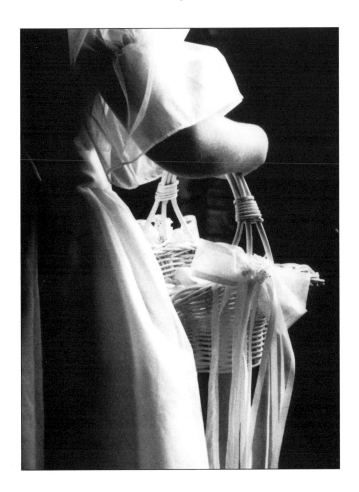

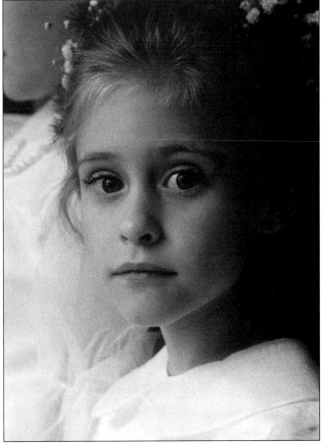

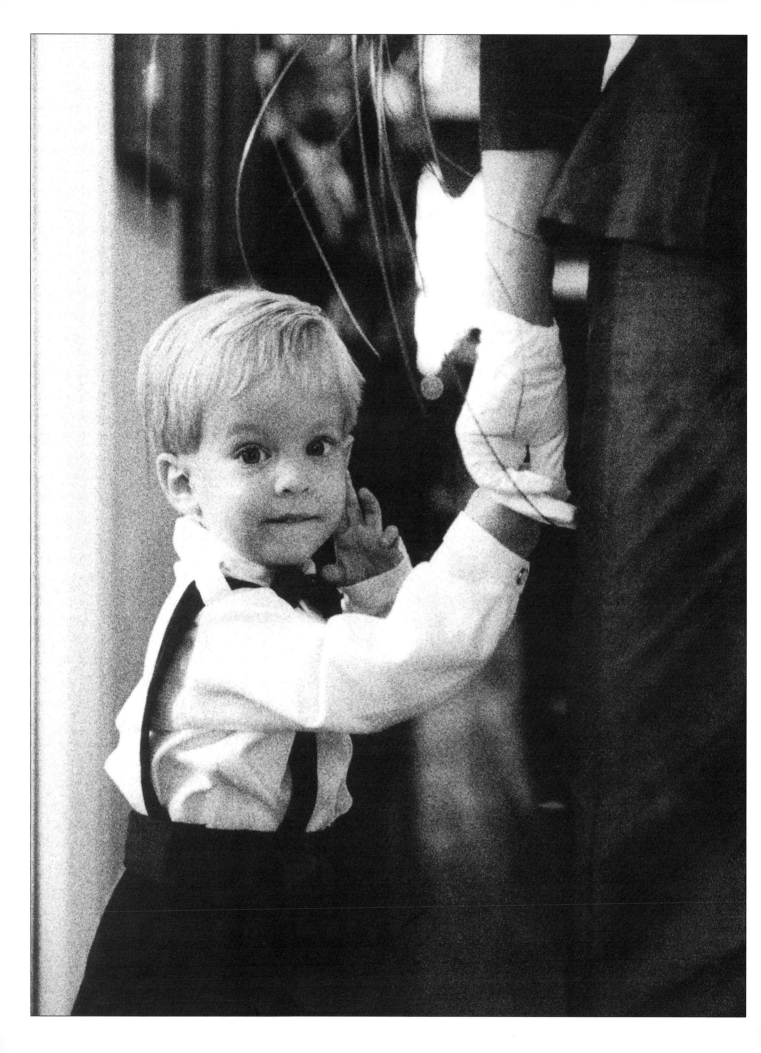

Tender When I Want to Be

Photography

Technically speaking, the film (Kodak TMZ 3200 black and white) was exposed ISO 3200, pushed processed one stop and printed with a #3 1/2 filter on Kodak PolyMax RC II paper, E surface. Using the film at this speed produces a beautiful, nostalgic image with a nice grain structure – perfect for the emotionally charged and artistic details at weddings. If you want less contrast, expose the film at 1600 and process regularly. This gives less grain and a softer look. If you are photographing in a contrasty lighting situation, use the latter combination. If the light is flat or a very low light situation, use the higher speed and push processing. We are also experimenting with the new Kodak T400 CN film, exposing at ISO 1250 and push processing it. So far the results are very nice. It has less grain and can be printed in black and white or sepia tone. Instead of proofing all of the exposures, we have the film processed and not cut. We edit the film with the Fujix FV-7 and only have the lab print the best exposures.

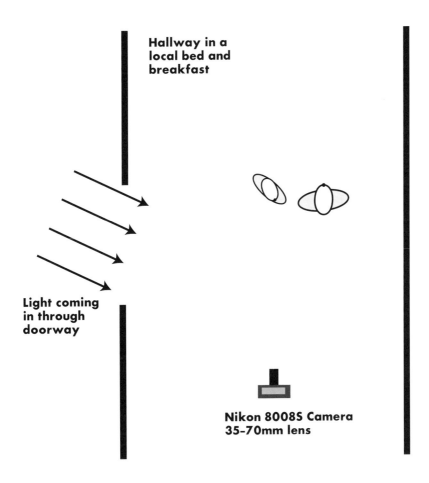

Hallway in a local bed and breakfast

Light coming in through doorway

Nikon 8008S Camera 35-70mm lens

Fill Flash (or Not)

Pose

When photographing at a wedding, you have to work quite fast and with minimum equipment. I sat the young flower girl on the antique couch at the bed and breakfast where the wedding was held. I tucked her right foot under her other leg. This keeps the legs from becoming too prominent in the image and it allowed me to turn her a little more toward the window.

Props

Her outfit and the flower basket were the props. I chose this couch because it matched the color of her dress.

Photography

One thing you have to realize about photography is that film and photographic paper sometimes can not record a scene the way the eye sees it. Sometimes the contrast range is more than the film can handle. That is when supplimental light is needed to bring the contrast levels into the range of the film. The image below is how the film "saw" the scene without additional light. The image on the opposite page is the way the eye saw the scene. To achieve the opposite image, I needed to add light to the front of the subject. I used the Quantum Q-Flash mounted on the camera with a Stroboframe flash bracket. This bracket places the flash unit directly above the lens which keeps the light from causing unnatural shadows on one side or the other of the subject. I like the Q-Flash for several reasons. It utilizes an automatic eye that give the proper exposure by controlling the amount of light the flash gives off. Also the flash unit is adjustable in 1/3 stops which gives me a tremendous amount of control. The flash head rotates 180° vertically and 360° horizontally. I pointed the flash straight up toward the ceiling and placed my hand directly above the flash head, held at a 45° angle, to bounce some of the light toward the subject. The rest of the light hits the ceiling and bounces around the room providing additional illumination. I read the light coming through the window hitting the face. The ambient light hitting the plane of the subject facing the camera was 4 stops less. This was too much contrast for the way I visualized the image, so I set the flash one stop lower than the light coming through the window. I also like the image on the bottom; it is more moody. I also knew the bride would probably like the photograph on the opposite page. However, by learning to use the "tools of the trade" I was able to create both images. The film used was Kodak PPF. The exposure was 1/30 second at f-5.6. The flash was set at f-4.

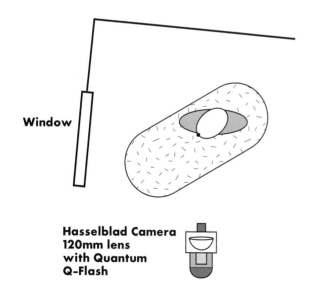

Window

**Hasselblad Camera
120mm lens
with Quantum
Q-Flash**

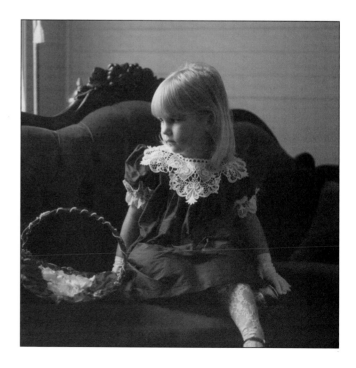

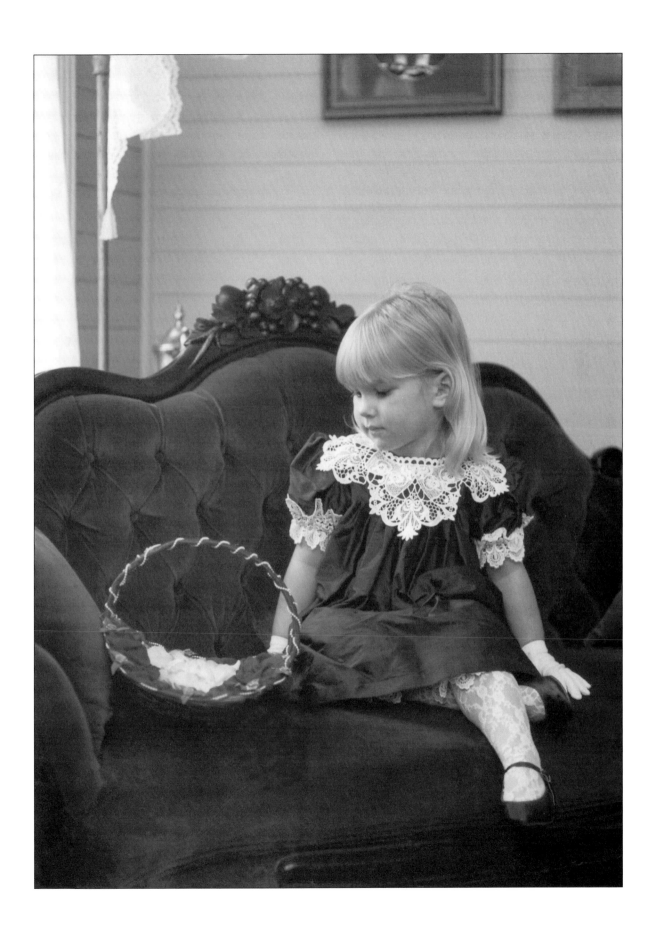

Window Light Flower Girl

Pose

While photographing a wedding, I did a series of images of the bride and flower girl. I love working with indirect light (instead of direct sunlight) coming through large windows. This window was large and had a set of vertical blinds. The blinds allowed me to control the amount of light coming through and hitting the subjects. I turned the bride slightly away from the window. This increases the texture on her gown by bringing the light across the front of the dress. I positioned the flower girl so that she did not cover the dress. This also gives each subject her own space.

Props

The props are the flowers and basket. Because the flowers are close to the light source, they are brighter than the faces. Since the flowers, and especially the bride's bouquet, are a big part of weddings, it doesn't bother me. I could have 'custom printed' the image and burned down the flowers (burning down is a darkroom term that means to darken by allowing more light from the enlarger to fall on a certain part of the image). Another solution would be to place the image in an oval mat which would cover part of the flowers.

Photography

Whenever using window light, you can increase the contrast of the light on the subject by moving them closer to the window, and decrease the contrast by moving the subjects away from the light source. Because the window was so large I did not need additional fill. Look at the quality of light on the faces. The film used was Kodak PPF. The camera is set for 1/30 second at *f*-4.

Psychology

The beauty of photographing a wedding is the relationships you build with the participants. Typically I get down on the child's level and talk to him/her about the "big job" he/she will be doing that day. Sometimes if I need a child to look out a window, I will have his or her mom go outside. Then I instruct the child to look at mom. This gets mom out of the room, and ensures she won't be saying "Smile, honey, smile!" when I want a sensitive expression.

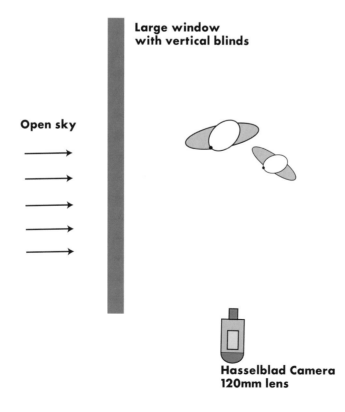

Large window with vertical blinds

Open sky

Hasselblad Camera 120mm lens

Children's Storybook

Sometimes I want to tell a story, to capture a moment in a child's life. We put an album together with words, poems, titles and even "quotes" from the child.

This is a series of the "story book" style of photography. Sometimes I do a session with the goal of one image. I'm looking for something nice to hang on the wall, an art piece or a design piece as an accessory for a room. Other times I want to tell a story and capture a special time in a child's life. That is the case with this series. The little girl's mom was going to have a new baby soon. We wanted to capture this stage in her life and the things happening to her before the new baby arrived.

This series was photographed by myself and my wife Barbara. Barbara used the Nikon 8008S and Kodak T-Max 400 CN film. This is a wonderful new film by Kodak for black and white images. The beauty of the film is that it is developed in regular color chemistry. That means that any local or one hour lab can process and print the film. This saves you money and time. It also can be printed in a rich brown tone, a cool blue tone as well as traditional black and white. The black and white has a selenium toned look that is very pleasing.

I used the TMax 400CN rated at ISO 400 in the medium format size. Many of the images I did and all of the images Barbara did were done with available light. With her film we used a technique called "pushing." To do this, set the ISO (film speed) to a higher rating than the film is normally rated for. In this case we chose ISO 1250. This allowed Barbara to hand hold the camera and use a sufficiently high shutter speed so as to prevent camera movement problems. When you're done, have your lab push process the film, making sure to let them know at what speed you exposed the film.

Typically, this will increase the grain (see the image "Tender When I Want To Be" on page 106) and the contrast. This can be a nice effect if you like it. I have included images from both my camera and Barbara's.

I really enjoy having two camera systems and photographers shooting our storybook sessions. It gives two different perspectives to the story and to the photography. The Nikon is an amazing piece of equipment. Its automatic averaging mode takes care of the technical side of photography and allows Barbara to concentrate on the artistic and story telling aspect of the session.

The storybook session can be a very creative session because you get several images to tell the story instead of just one. We put an album together with words, poems, titles and even 'quotes' from the child. The final product is designed as a coffee table style album. Be creative in coming up with themes and stories. Also, be sure to work with the moms and get their input.

The album we use is made by Art Leather (see the suppliers' list at the back of this book). They make several styles and sizes that will work for the story book collection. My favorite is called Mezzo.

Here are just a few example ideas for storybooks:
- Losing the First Tooth
- The First Birthday
- The First Haircut
- A Trip to the Zoo
- A Day at the Beach
- Visiting Grandmother
- The New Puppy
- The New Baby

On the following pages are some of the images from a recent story book session, "The New Baby!"

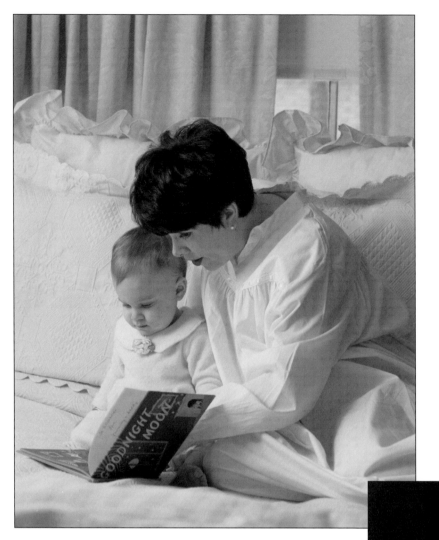

Once upon a time, there was a wonderful young girl. She lived at home with her mommy, daddy, and her dog, Sally.

Very, very soon someone new was going to arrive at her home.

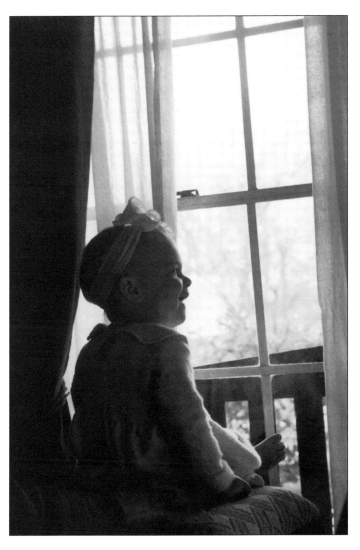

She didn't quite understand how the new person would arrive, but everyone told her it would be soon!

Mommy was excited about the new arrival.

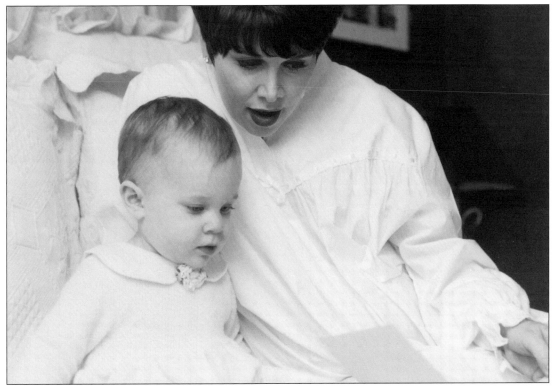

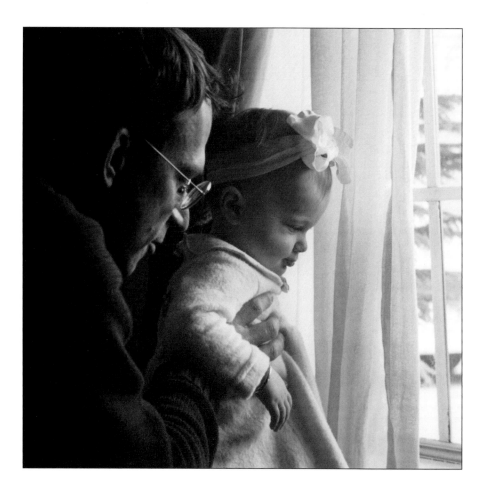

Daddy was also excited!

What confused her most was that mommy's tummy was growing.

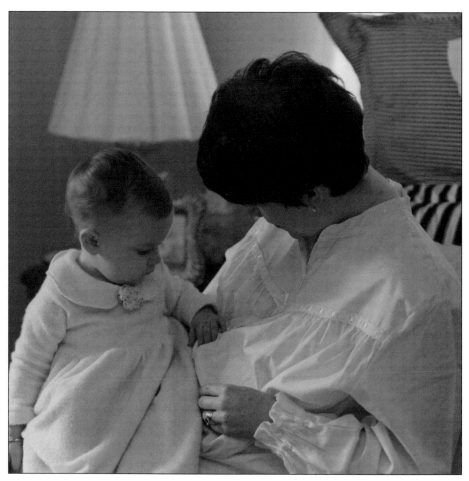

Mommy said
the new baby
was in her
tummy. In her
tummy?

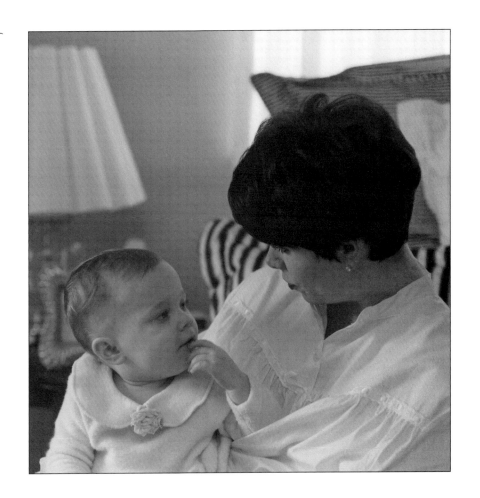

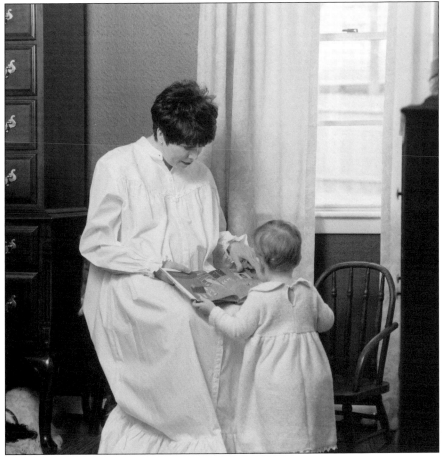

I like when
Mommy reads
me stories about
babies.

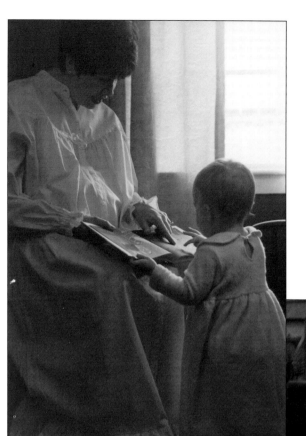

That baby looks just like me!

Sally, the baby will have a nose and eyes and ears.

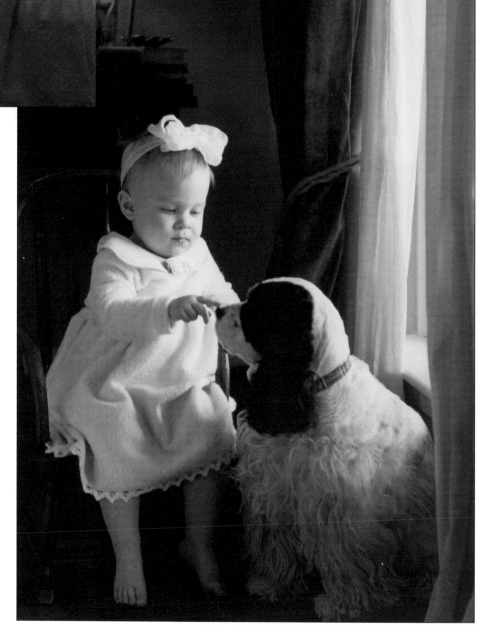

Do you think the baby's feet will look like mine or yours?

I think they will look like mine!

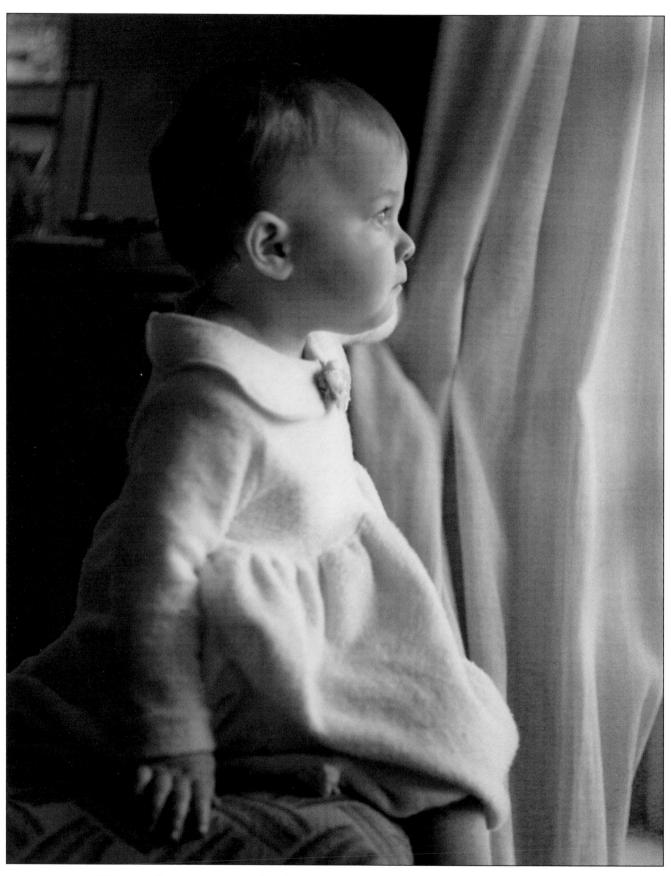

I can't wait! I hope the baby comes soon.

Children's Portrait Guidelines

This is a handout which I provide to clients to help them plan a portrait session.

Several factors are important in creating beautiful children's portraits: location, clothing and lighting. I will take care of the lighting. Together we will discuss the location and find the best place to create the portrait. Clothing is your department. It is one of the most important factors in portraiture.

Usually, simple clothing photographs best. Avoid loud patterns and bright colors. I believe the clothing should reflect the personality of the child. We will assist you in picking the best clothing for the portrait. We have assembled a collection of "proper" clothing samples to aid you in this task. Hats make great accessories for children, but don't put the hat on until we have had time to do some hatless images. Put as much thought into shoes as you do with the rest of the outfit. On small children the shoes are often in the photographs. Little bare feet have a lot of personality. I often photograph them.

I do a lot of children's portraits in their own room. Moms relax – the whole room does not have to be perfectly clean. Many times a small corner, at a window or on the child's bed, is all we need. The best thing about photographing in the child's own room is they feel comfortable there. Also I can use the child's own toys, books and other personal items in the portraits. All of these factors give security and add to the personalization of the portraits and will add to your enjoyment for many years to come.

Smiles are beautiful on children, especially on close- up images. Soft expressions are especially good with the more sensitive or reflective portraits. Please don't instruct children to say silly words like 'cheese' or tell them to smile for Mr. Box. Natural expressions, soft smiles and spontaneous looks on children make for enduring portraits.

Children usually do best when siblings or relatives are not brought along for the portrait session. Extra people can be distracting and could hurt the portrait.

For outdoor portraits, the best time for the lighting is the last hour of daylight. The second best time is the first hour of the day, however because it is so early, some children may not do as well at this time. Another consideration in scheduling the time is the child's routine. When does he usually nap or rest? What is his normal time to eat?

If you feel your child is very shy or takes a while to warm up to strangers, we can schedule something I call "play time." You can bring the child to the studio a day or two before the session to just play with Mr. Box and all of his toys. Or, if we are doing the portrait at your home, I can stop by there and have this play time. This will give me a chance to meet with your child. It will also give me time to look around to find the best place for the portrait.

A good portrait of a child should not be rushed. Depending on how your child reacts we may spend as little as thirty minutes or as long as an hour or two creating the images. Many times the first ten to fifteen minutes are just "get acquainted" time.

Sometimes it is good to have a parent in the room during the session, sometimes it is not. Many times I will start with the parent in the room and let them slowly slip out during the session.

If you feel like the child is not in the proper mood for the portrait or is not feeling good, don't hesitate to call so we can re-schedule if necessary.

Additional Information

Special Thanks To:
Burrel Color
1311 Merrville Rd.
Crown Point, IN 46307
(800)348-8732
They printed all the images used in this publication.
If you are looking for a lab, I recommend them.
They have ten locations across the country.

The author is also available for personal and small group consultations in the areas of
- Children's Photography
- Wedding Photography
- Family and Senior Photography
- General Business Operations

Please contact the author through his publisher by calling 1(800)622-3278.

Suppliers

•Photographic Watercolor Art Prints
Pacific Color of Seattle Washington
(800)552-7407

•Cameras
Hasselblad 500 CM
Major lenses 120mm, 150mm, 250mm
Hasselblad USA (201) 227-7320

Nikon 8008S
(800) NIKON US

•Meters
Minolta IIIf with the optional flat disk
Minolta USA (201) 825-4000

Sekonic L508 Zoom Meter
Sekonic USA
(914) 347-3300

•Tripod
Bogen 3050, 3021, Bogen camera stand
(201) 818-9500

•Children's Story Book Albums
Art Leather
(888) AL-ALBUMS

•Chairs and Other Children's Props
American Photographic Resources
(800) 657-5213

•Lighting Equipment
Photogenic Flash Master, Power
Lights, Umbrellas, Silver Reflector
Photogenic Professional Lighting Co.
(800) 682-7668

•Professional Lens Shade
Lindahl Specialties
(219) 296-7823

•Painted Backgrounds and Muslins
Les Brandt Backgrounds
(800) 462-2682

•Professional Organizations
Professional Photographers of America
(800) 786-6277
Wedding & Portrait Photographers Int
(310) 451-0090

•Film
Eastman Kodak PPF, VPS, VPH, TXP
TMZ, TMax 400 CN, Ektalure G Paper
(800) 657-5213

Index

Other Books from Amherst Media, Inc.

Basic 35mm Photo Guide
Craig Alesse

Great for beginning photographers! Designed to teach 35mm basics step-by-step — completely illustrated. Features the latest cameras. Includes: 35mm automatic and semi-automatic cameras, camera handling, *f*-stops, shutter speeds, and more! $12.95 list, 9x8, 112p, 178 photos, order no. 1051.

Camera Maintenance & Repair
Thomas Tomosy

A step-by-step, fully illustrated guide by a master camera repair technician. Sections include: testing camera functions, general maintenance, basic tools needed, basic repairs for accessories, camera electronics, plus "quick tips" for maintenance and more! $24.95 list, 8½x11, 176p, order no. 1158.

Don't Take My Picture
Craig Alesse

This is the second edition of the fun-to-read guide to taking fantastic photos of family and friends. Best selling author, Craig Alesse, shows you in clear, simple language how to shoot pictures, work with light, and capture the moment. Make everyone in your pictures look their best! $9.95 list, 6x9, 104p, 100+ photos, order no. 1099.

Camera Maintenance & Repair Book 2
Thomas Tomosy

Advanced troubleshooting and repair building on the basics covered in the first book. Includes; mechanical and electronic SLRs, zoom lenses, medium format, troubleshooting, repairing plastic and metal parts, and more. $29.95 list, 8½x11, 176p, 150+ photos, charts, tables, appendices, index, glossary, order no. 1558.

Build Your Own Home Darkroom
Lista Duren & Will McDonald

This classic book shows how to build a high quality, inexpensive darkroom in your basement, spare room, or almost anywhere. Information on: darkroom design, woodworking, tools, and more! $17.95 list, 8½x11, 160p, order no. 1092.

Restoring Classic & Collectible Cameras
Thomas Tomosy

A must for camera buffs and collectors! Clear, step-by-step instructions show how to restore a classic or vintage camera. Work on leather, brass and wood to restore your valuable collectibles. $34.95 list, 8½x11, 128p, b&w photos and illustrations, glossary, index, order no. 1613.

Into Your Darkroom Step-by-Step
Dennis P. Curtin

The ideal beginning darkroom guide. Easy to follow and fully illustrated each step of the way. Information on: equipment you'll need, set-up, making proof sheets and much more! $17.95 list, 8½x11, 90p, hundreds of photos, order no. 1093.

Big Bucks Selling Your Photography
Cliff Hollenbeck

A complete photo business package for all photographers. Includes secrets to making big bucks, starting up, getting paid the right price, and creating successful portfolios! Features setting financial, marketing and creative goals. This book will help to organize business planning, bookkeeping, and taxes. $15.95 list, 6x9, 336p, order no. 1177.

The Wildlife Photographer's Field Manual

Joe McDonald

The complete reference for every wildlife photographer. A practical, comprehensive, easy-to-read guide with useful information, including: the right equipment and accessories, field shooting, lighting, focusing techniques, and more! Features special sections on insects, reptiles, birds, mammals and more! $14.95 list, 6x9, 200p, order no. 1005.

Infrared Photography Handbook

Laurie White

Covers black and white infrared photography: focus, lenses, film loading, film speed rating, heat sensitivity, batch testing, paper stocks, and filters. Black & white photos illustrate how IR film reacts in portrait, landscape, and architectural photography. $24.95 list, 8½x11, 104p, 50 b&w photos, charts & diagrams, order no. 1419.

The Art of Infrared Photography / 4th Edition

Joe Paduano

A practical, comprehensive guide to the art of infrared photography. Tells what to expect and how to control results. Includes: anticipating effects, color infrared, digital infrared, using filters, focusing, developing, printing, handcoloring, toning, and more! $29.95 list, 8½x11, 112p, order no. 1052.

Infrared Nude Photography

Joseph Paduano

A stunning collection of images with informative how-to text. Over 50 infrared photos presented as a portfolio of classic nude work. Shot on location in natural settings, including the Grand Canyon, Bryce Canyon and the New Jersey Shore. $29.95 list, 8½x11, 96p, over 50 photos, order no. 1080.

Black & White Nude Photography

Stan Trampe

This book teaches the essentials for beginning fine art nude photography. Includes info on finding your first models, selecting equipment, scenarios of a typical shoot, and more! Includes 60 photos taken with b&w and infrared films. $24.95 list, 8½x11, 112p, index, order no. 1592.

Swimsuit Model Photography

Cliff Hollenbeck

A complete guide to swimsuit model photography. Includes: finding and working with models, selecting equipment, posing, props, backgrounds, and much more! By the author of *Big Bucks Selling Your Photography* and *Great Travel Photography*. $29.95 list, 8½x11, 112p, over 100 b&w and color photos, index, order no. 1605.

Glamour Nude Photography

Robert and Sheila Hurth

Create stunning nude images! Robert and Sheila Hurth guide you through selecting a subject, choosing locations, lighting, and shooting techniques. Includes information on posing, equipment, makeup and hair styles, and much more! $24.95 list, 8½x11, 144p, over 100 b&w and color photos, index, order no. 1499.

Wedding Photographer's Handbook

Robert and Sheila Hurth

The complete step-by-step guide to succeeding in the exciting and profitable world of wedding photography. Packed with shooting tips, equipment lists, must-get photo lists, business strategies, and much more! $24.95 list, 8½x11, 176p, index, b&w and color photos, diagrams, order no. 1485.

Lighting for People Photography

Stephen Crain

The complete guide to lighting. Includes: set-ups, equipment information, how to control strobe and natural lighting, and much more! Features diagrams, illustrations, and exercises for practicing the lighting techniques discussed in each chapter. $29.95 list, 8½x11, 112p, b&w and color photos, glossary, index, order no. 1296.

Handcoloring Photographs Step-by-Step

Sandra Laird & Carey Chambers

Learn to handcolor photographs step-by-step with the new standard handcoloring reference. Covers a variety of coloring media. Includes colorful photographic examples. $29.95 list, 8½x11, 112p, 100+ color and b&w photos, order no. 1543.

Special Effects Photography Handbook

Elinor Stecker Orel

Create magic on film with special effects! Little or no additional equipment required, use things you probably have around the house. Step-by-step instructions guide you through each effect. $29.95 list, 8½x11, 112p, 80+ color and b&w photos, index, glossary, order no. 1614.

Achieving the Ultimate Image

Ernst Wildi

Ernst Wildi shows how any photographer can take world class photos and achieve the ultimate image. Features: exposure and metering, the Zone System, composition, evaluating an image, and much more! $29.95 list, 8½x11, 128p, 120 B&W and color photos, index, order no. 1628.

Black & White Portrait Photography

Helen Boursier

Make money with B&W portrait photography. Learn from top B&W shooters! Studio and location techniques, with tips on preparing your subjects, selecting settings and wardrobe, lab techniques, and more! $29.95 list, 8½x11, 128p, 130+ photos, index, order no. 1626.

Profitable Portrait Photography

Roger Berg

Learn to profit in the portrait photography business! Improves studio methods, shows lighting techniques and posing, and tells how to get the best shot in the least amount of time. A step-by-step guide to making money. $29.95 list, 8½x11, 104p, 120+ B&W and color photos, index, order no. 1570.

Lighting Techniques for Photographers

Norm Kerr

This book teaches you to predict the effects of light in the final image. It covers the interplay of light qualities, as well as color compensation and manipulation of light and shadow. $29.95 list, 8½x11, 120p, 150+ color and b&w photos, index, order no. 1564.

Computer Photography Handbook

Rob Sheppard

Learn to make the most of your photographs using computer technology! From creating images with digital cameras, to scanning prints and negatives, to manipulating images, you'll learn all the basics of digital imaging. $29.95 list, 8½x11, 128p, 150+ photos, index, order no. 1560.

Amherst Media's Customer Registration Form

Please fill out this sheet and send or fax to receive free information about future publications from Amherst Media.

CUSTOMER INFORMATION

DATE

NAME

STREET OR BOX #

CITY STATE

ZIP CODE

PHONE () FAX ()

OPTIONAL INFORMATION

I BOUGHT *PHOTOGRAPHING CHILDREN* BECAUSE

I FOUND THESE CHAPTERS TO BE MOST USEFUL

I PURCHASED THE BOOK FROM

CITY STATE

I WOULD LIKE TO SEE MORE BOOKS ABOUT

I PURCHASE BOOKS PER YEAR

ADDITIONAL COMMENTS

FAX to: 1-800-622-3298

①

②

Name_____
Address_____
City_____State_____
Zip_____ — _____

Amherst Media, Inc.
PO Box 586
Buffalo, NY 14226

③